max ernst

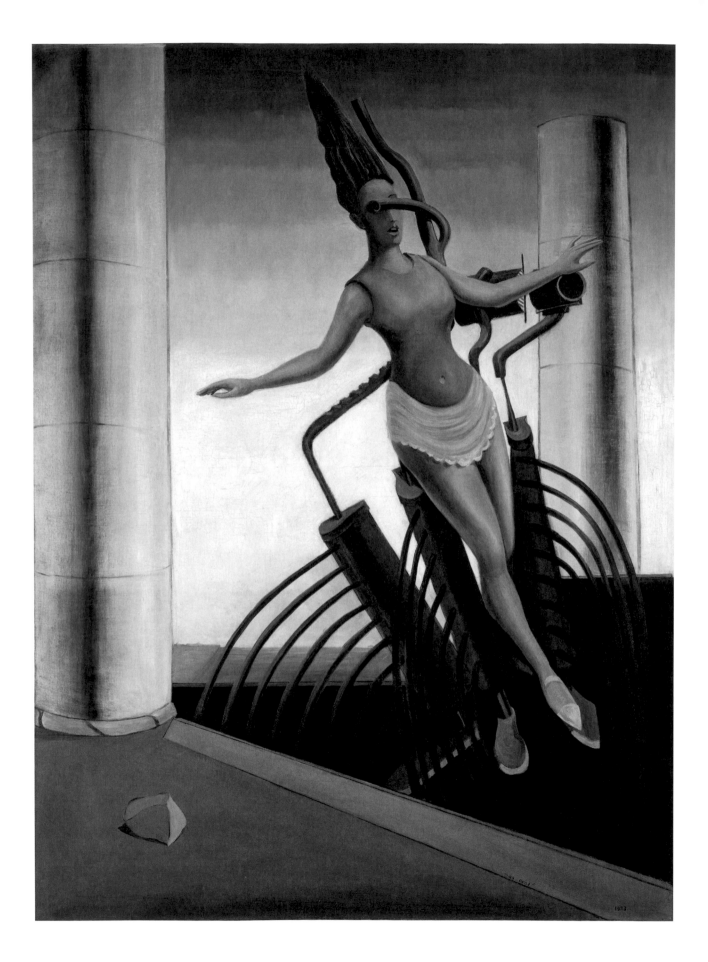

ULRICH BISCHOFF

MAX ERNST

1891–1976

Beyond Painting

TASCHEN

Contents

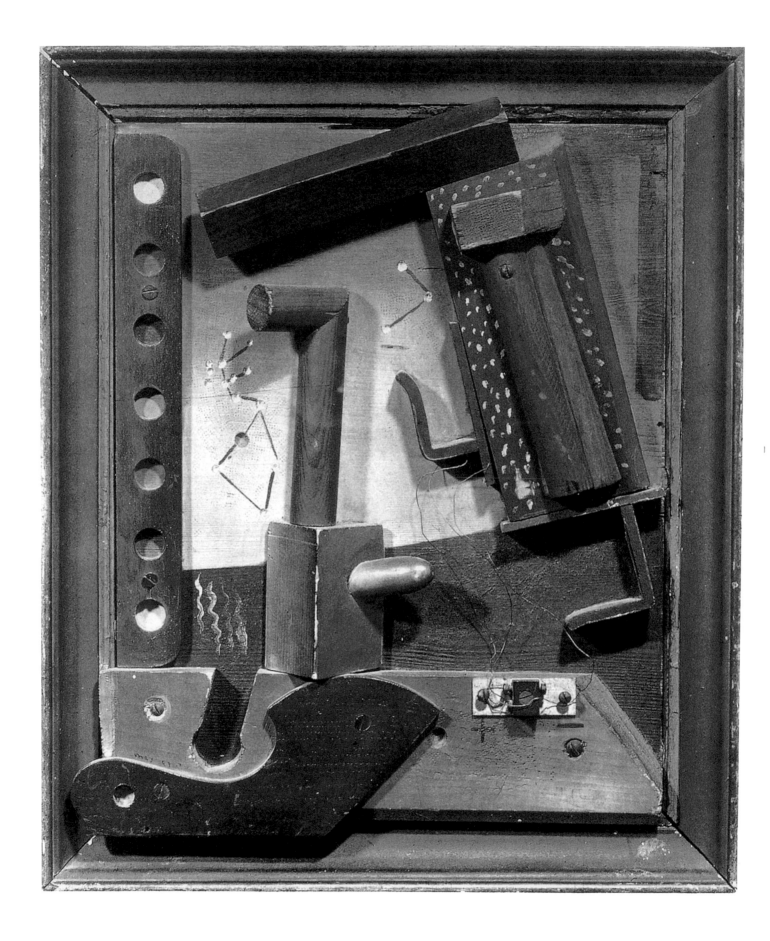

Withdrawal from Art History
1912–1921

Facts in the life of Max Ernst are seldom to be relied upon. If we make the attempt to delve into the biography of this man, now recognized as the outstanding artist that he was, we are confronted by a fine "Tissue of Lies and Truth" as Max Ernst himself subtitled his autobiography. It was part of his particular brand of artistic originality to set traps into which the analytical investigator will invariably stumble. Since these traps were laid by the master himself with a certain reason in mind, they may be of help to us in our attempt to get to know the "real" Max Ernst and his work.

At the beginning, we have a portrait of the five-year-old boy in the guise of the Christ Child with one hand raised in blessing, painted in 1896 by his father, Philipp Ernst, who was an active amateur artist himself (ill. p. 7). In his autobiography, Ernst's early sense of artistic vocation becomes apparent in the story of "The Secret of the Telegraph Wires": "When one observes them through the window of one's compartment they swing heavily when the train is in motion, but when it comes to a halt, they suddenly stand still. In order to get to the bottom of this mystery, he slipped away from his parents' home one afternoon. Barefoot and dressed in a red 'punjel' (a long robe), with blond curls and blue eyes and carrying a whip in his left hand, the vagabond aroused the admiration of Kevelaer pilgrims coming along the path. 'The Christ Child' they whispered, full of awe. Believing them, the boy walked on in their midst, leaving them at the railway embankment to get to the bottom of the mystery of the telegraph wires. Discovered and brought home. Irate Papa. 'I am the Christ Child.' Placation, reconciliation. Father Philipp then painted the son as the child Jesus, standing on a little cloud in a red punjel, with an elegant crucifix (instead of the whip) and his hand making a gesture of benediction." The meaning the telegraph wires took on in this incident is reflected in oil studies done in 1912, where they are repeatedly depicted (ill. p. 8 top). Railway lines, telegraph wires and signalmen, all privy to such "secrets," stood for the boy's yearning for faraway places.

Several drawings dating from Max Ernst's school days at a classical grammar school in Brühl are still in existence, demonstrating his critical and ironical attitude towards the elite living in this provincial town at the end of the reign of Kaiser Wilhelm II and their bourgeois attitude to culture. He did not exclude himself from this view of the world, caricaturing himself as a painter, set on the plinth of a monument. The slouch hat and an outsize palette show him to be an artist. Beneath the caricature a verse is quoted from Wilhelm Busch: "A young man hopeful for a start/In life can learn the painter's art" (ill. p. 8 bottom right). Max Ernst also did a drawing of a "finals" celebration at the time, labelling it a "pupil's party," This drawing was

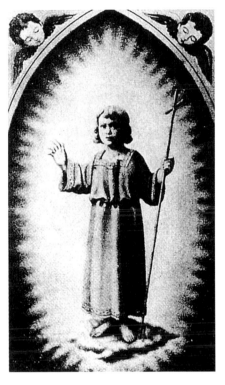

Philipp Ernst
Portrait of Max Ernst as the Child Jesus, 1896

Fruit of a Long Experience,
1919
Assemblage; painted wood and wire, 45.7 × 38 cm
(18 × 15 in.)
Private collection

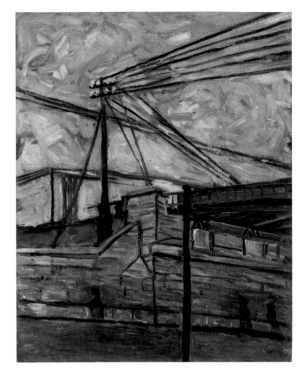

Railway Underpass at Comesstrasse, 1912
Oil on cardboard, 46 × 36 cm
(18⅛ × 14¼ in.)
Brühl, Max Ernst Museum,
Stiftung Max Ernst

more than a mere illustration of a harmless and lighthearted gathering, it was a caricature of a whole class of society.

After leaving school in March 1910, Max Ernst began to study liberal arts at the University of Bonn. He was interested in "seditious philosophy and unorthodox poetry" and also took up the study of Germanic and Romance languages and literature, art history, psychology and psychiatry. Although his statement that he avoided studying anything "that faintly involved the possibility of earning a living" is not to be contradicted, it would be wrong to think that he led an idle life during this time. The knowledge of art history that he acquired during these years from within, as it were, had a determining effect on his confrontation with art and its code of values. Just as Marcel Duchamp reacted to the way exhibitions were run with his "readymades," introducing a new quality to art in the process, the early work done by Max Ernst, especially in the period after 1919, also demonstrated a conscious departure from the prevalent bourgeois culture of his time.

While painters such as George Grosz, Otto Dix and Max Beckmann dealt with the experiences they had during the Great War in a fruitful way, Max Ernst's work in the period after 1919 was more concerned with an ironical exposure of the values which had helped cause this terrible massacre, for he had established contact to the Dadaists in Zurich and Berlin during the war. In composition and colour, the *Family Excursion* of around 1919 (ill. p. 9) is also reminiscent of the Russian-Jewish world of that great poetic artist, Marc Chagall, but here the happy atmosphere of the family outing takes on a sombre air.

In late summer 1919, Max Ernst visited Paul Klee in Munich. He had already seen some of his work at Goltz's bookshop and now he asked him for the loan of several paintings for an

From Life at School, 1910
Drawings for the school
magazine of the same name

Family Excursion, c. 1919
Oil on canvas, 36 × 26 cm
(14¼ × 10¼ in.)
Prague, Národní galerie

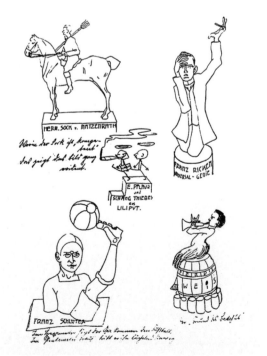

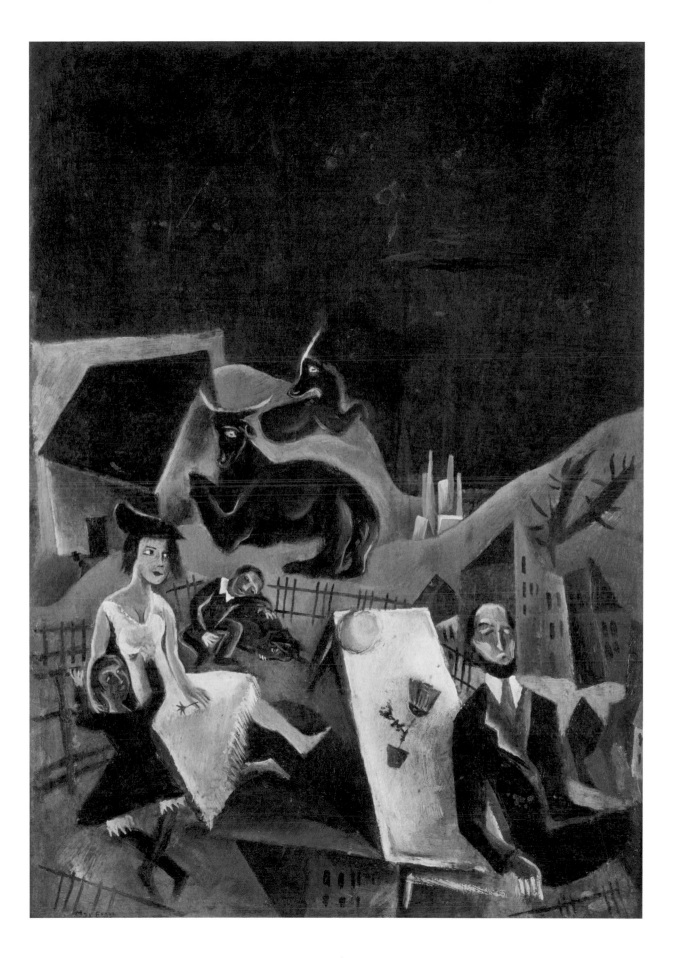

Aquis submersus, 1919
Oil on canvas, 54 × 43.8 cm
(21³⁄₈ × 17¼ in.)
Frankfurt am Main,
Städel Museum

Dada Gauguin, 1920
Gouache and ink on
printed paper, 30.3 × 40 cm
(12 × 15¾ in.)
The Art Institute of Chicago,
Gift of Maurice and Muriel
F. Fulton

exhibition to take place in Cologne. At Goltz's he also saw a few copies of *Valori plastici,* an Italian magazine. Illustrations of works by the painters Giorgio de Chirico and Carlo Carrà, exponents of the "pittura metafisica" movement, had a long-lasting effect on him. *Aquis submersus* is a response to this encounter (ill. p. 11). Here he adopted the use of a background laden with meaning and a strictly centralized perspective which draws everything together into a state of breathless tension, but he lent the whole an ironical touch of his own. The magical source of light, the full moon, is a clock, but when it is reflected in the swimming-pool it becomes a moon again. Architectural units like building blocks surround the pool like stage "extras," standing as if in witness of the extraordinary scene taking place before them. In the foreground a male figure like a tailor's dummy can be seen. Apart from the circular openings, which represent nipples, navel and the sexual organs, its most conspicuous detail is the moustache with its ends pointing upwards like the hands of a clock. In the swimming-pool the vertical figure of what seems to be a woman is sinking to the ground. This probably gave rise to the title of the painting, which is also a reference to the mysterious Latin title of a novella by Theodor Storm. Translated, "aquis submersus" means "to meet one's end" or "to reach the bottom of the water," thus increasing the irony of the painting on a linguistic level.

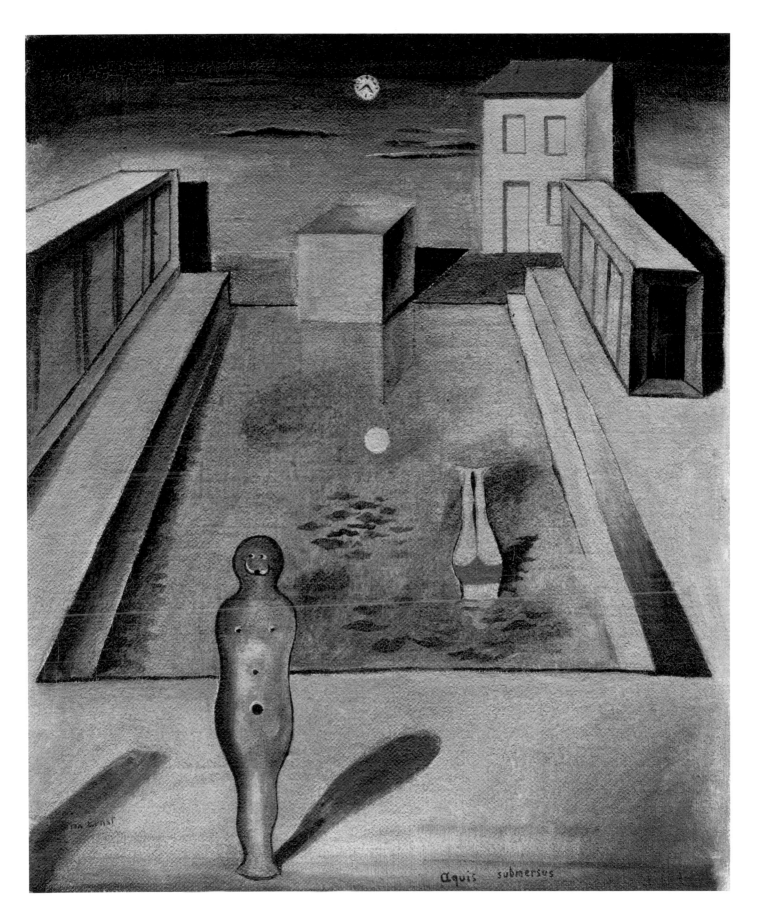

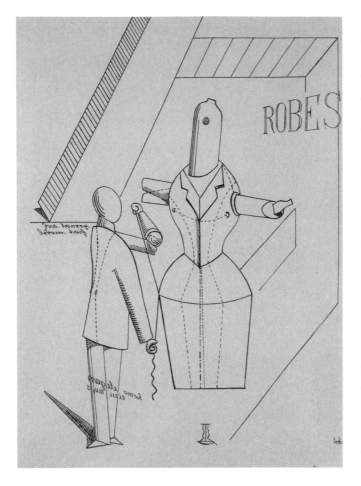

In *Family Excursion*, Max Ernst had made something new of Chagall's Futurist and Cubist-based method of painting by altering it and adding new attributes of his own, something he also did with de Chirico's and Carrà's Italian style in *Aquis submersus*. From now on, he was only to make use of material that had little or nothing to do with art. For a while, the collage became his most important means of creating pictures. Here his point of departure was his interest in objects that had been laid or cast aside or which were no longer modern.

The assemblage *Fruit of a Long Experience* (ill. p. 6) is one of a small group of objects which were made of found pieces of wood combined to form a picture with the help of a frame and paint. The title refers to a statement frequently used by art critics to explain artistic quality. At this time, he also produced sculptural constructions which generally took on human shape, made of differing materials, such as plaster, pieces of wood and flowerpots, for exhibitions in Cologne. Most of these objects have since been destroyed. Other three-dimensional constructions were made out of large wooden letters, characters and stereotype plates from printing workshops in Cologne, and, most especially, out of hat pressing moulds taken from the factory belonging to Jacob Strauss, Max Ernst's father-in-law. In *Fruit of a Long Experience*, non-identifiable used wooden parts are connected by wires leading from output screws marked "plus" and "minus." The clearly recognizable attempt to veil the identity of the materials used as far as possible is characteristic of the style of these assemblages.

Max Ernst submitted these works to exhibitions taking place within the conventional framework of the Cologne Art Association as well as in rented rooms. On the occasion of the exhibition held in Winter's Brewery with Johannes Theodor Baargeld (a pseudonym for Alfred Grundewald, 1892–1927), both artists were summoned to appear in the headquarters of the Cologne police, where they were accused in the following manner: "You are swindlers, both of you, frauds and scoundrels... you are accused of fraud, for having demanded admission for something that was announced to the public as being an art exhibition, but which in reality has nothing to do with art." In the end, the exhibition was closed on the grounds of obscenity. Another exhibition in Düsseldorf aroused the attention of the daily press, which commented: "In 'Junges Rheinland,' Max Ernst attracted attention with the naivety of his primitive paintings. Since then he has regressed to a state of childhood to such an extent that he is now, in all seriousness, sticking old reels, cotton-wool remains and wire together into 'Knotted Sculptures' along with dolls' arms and legs, cogs and wheels from watches and whatever else is to be found in the junk room. Not even the best-disposed of visitors knows what to make of these objects."

Ernst's collages of printed matter are of greater significance than the assemblages of material described above. Out-of-date textbooks from every branch of science were the favourite source of material for this unusually versatile, well-read and cultivated man, who also made use of books of master designs for crafts and trades. Another source of material proved to be the patterns used by cottage industries and he also used educational placards with their

Fiat modes pereat ars, 1919
Lithograph, 45.5 × 33 cm
(18 × 13 in.)
Jerusalem,
The Israel Museum

Untitled, 1920
Gouache, pen, ink and
pencil on printed paper
on cardboard, 30 × 25 cm
(11⅞ × 9⅞ in.)
Private collection

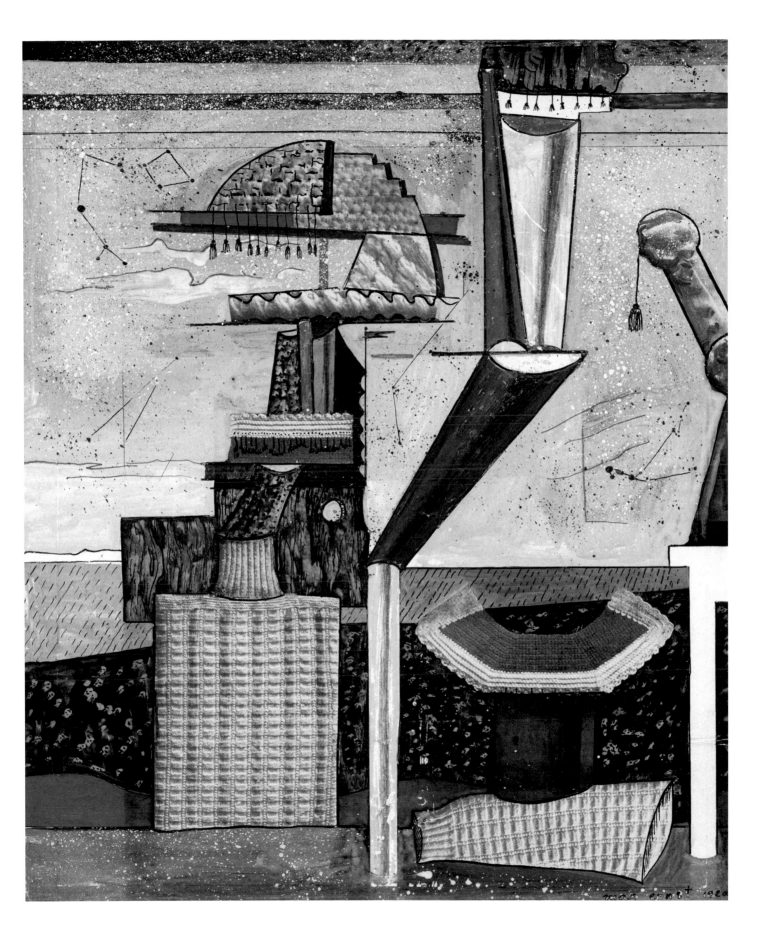

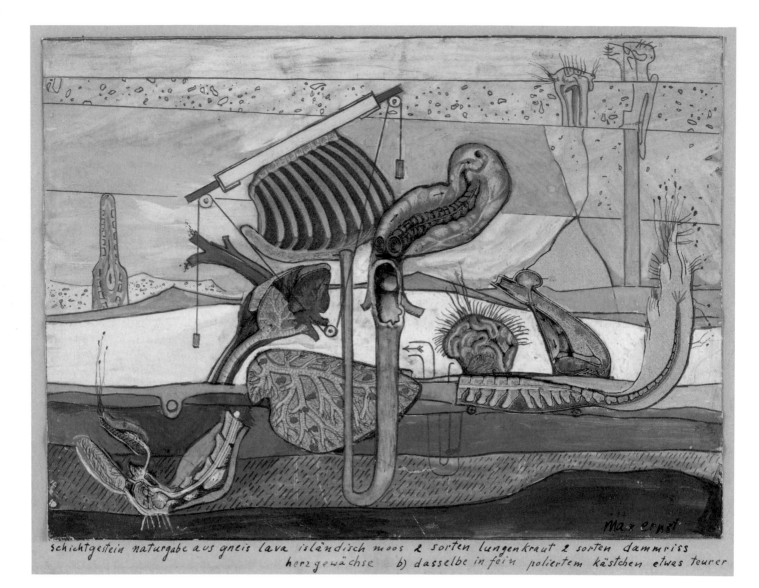

schichtgestein naturgabe aus gneis lava isländisch moos 2 sorten lungenkraut 2 sorten dammriss
herzgewächse b) dasselbe in fein poliertem kästchen etwas teurer

Stratified Rocks, Nature's Gift of Gneiss Lava Iceland Moss 2 kinds of lungwort 2 kinds of ruptures of the perinaeum growths of the heart b) the same thing in a well-polished little box somewhat more expensive, 1920
Gouache and pencil on printed paper on cardboard, 19.1 × 24.1 cm (7⅝ × 9½ in.)
New York, The Museum of Modern Art

instructions for carrying out scientific experiments. The artist had a deep dislike for all forms of manual work, which becomes clear in these collages. He associated the complacency of the cottage industry with the figure of the industrious housewife, who – diverting attention from the fact that she was a sexual being by knitting and crocheting in order to adorn herself and her home – was soon to become the target of his contempt.

In the case of the collage *Mine Hostess on the Lahn* (Staatsgalerie Stuttgart), printed crochet patterns are incorporated into a complicated system of interlocking cogs and mechanical devices with the help of opaque water colour and photocollage. The artist both commented on his picture and complimented it with the inscription: "Mine Hostess on the Lahn, guardian angel of the Germans, thine is the industry anatomy palaeontology give us small rejoicings," which was written along the bottom of the picture. This dedication not only brings the refrain of a well-known German students' song to mind, it is also a reference to Johanna Ey, a patron of the arts and owner of a Düsseldorf coffee-shop, who is not to be underestimated in her significance. With her establishment in mind, the rectangle in the middle of the picture can easily be interpreted as a door or an entrance. The mention of industry, anatomy and palaeontology

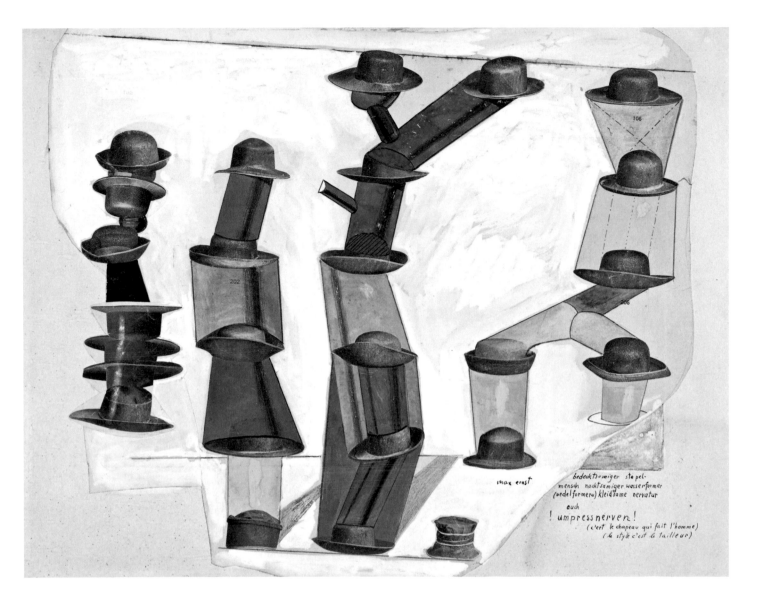

in the inscription can be assumed to refer to the source of materials used in these collages. At the same time, "industry" can also be seen as referring to the mechanical parts used in the collage as well as the interlocking of the elements of the picture in a way that does not appear to have any meaningful function. It also calls the industriousness of the diligent housewife to mind. The term "anatomy" can be seen as referring to dissection, to the laying bare of organs which lie below the skin, while in a concrete sense, it also alludes to the anatomy textbooks which provided some of the illustrations for other collages. Finally, "palaeontology," or the science of extinct life, alludes not only to the excavation of beings covered by earth but also to hidden layers of meaning.

This leads us to the most significant aspect in the interpretation of Max Ernst's collages. Sigmund Freud's discipline of psychoanalysis, especially his *The Interpretation of Dreams* and the essay *Leonardo da Vinci, A Memory of His Childhood*, provided Max Ernst with the theoretical help he needed to free himself of the constraints of art history. Without the conscious discovery of the unconscious, Dada and Surrealism would be inconceivable. Only when these facts are taken into consideration is it possible to understand why coincidence, incoherence

The Hat Makes the Man (C'est le chapeau qui fait l'homme), 1920
Gouache, pencil, oil and ink on cut-and-pasted printed paper on board
35.2 × 45.1 cm (13⅞ × 17⅞ in.)
New York, The Museum of Modern Art

Hypertrophic Trophy,
c. 1919/20
Cliché print, pen and Indian
ink on paper, 37.4 × 18.7 cm
(14¾ × 7⅜ in.)
Private collection

and eroticism were to play such an important role in the work of the Dadaists and the early Surrealists. However, unlike the Surrealists, Max Ernst did not see collage, and later frottage and grattage, simply as useful new techniques; for him the use of constituents having no relation to each other was the central tenet of his artistic intent.

The conscious incorporation of insights gained from reading Freud's *The Interpretation of Dreams and Jokes and their Relationship to the Unconscious* distinguishes Ernst from other artists of the Dada period. At the same time, it makes it all the more difficult to interpret his pictures from a psychoanalytical point of view. He gave crochet patterns new meaning each time he used them, as well as the silhouettes and outlines of figures which repeatedly appear in his work. In *Dada Gauguin* (ill. p. 10) for example, these "silhouettes" are repeated three times in the form of a flexible doll, perhaps in an ironical allusion to the supposed purity of Gauguin's Tahiti figures. At the same time, sexual forces in the form of an oversized stigma (a phallic symbol in plant form), an outsized auditory canal and a vagina-like sheath, cut open at the front, invade the purity of these stencil-like figures and disturb what is supposedly the paradisiac harmony of man and nature.

The "cardiac vegetation," "2 varieties of bladderwort" and "2 varieties of perineal hernia" which unmistakeably push into the centre of attention in the overpainted picture *Stratified Rocks, Nature's Gift of Gneiss Lava Iceland Moss 2 kinds of lungwort...* (ill. p. 14) give the incarceration of living beings in a landscape of rock strata and lava masses the appearance of a creation that also has gone wrong. In *Dada Gauguin*, silhouettes and stencil-like forms were used to take the place of the normal way of depicting people, drawing attention to the hollowness of such portrayals, while in the landscapes featuring illustrations from anatomy textbooks (cf. also ill. p. 18), the unity of the picture is based on elements which are basically contradictory. This unity, which consists of incompatible fragments of reality, is made possible by the concealed skill of the artist. Suddenly, the impossible becomes possible, questioning the validity of our way of seeing reality. The impossible takes place with the pathos of what is possible and normal.

One of the best-known collages from the Cologne period is the relatively large piece with the eloquent title of *The Hat Makes the Man* (ill. p. 15). Max Ernst once had to manage his father-in-law's hat factory for six weeks, during which he made sculptures (since destroyed) out of wooden hat-pressing moulds. In the case of this collage, he made use of a catalogue of hat forms. By turning the hats round, painting them over, and making his own additions, he created a totally new "structure," complemented by the following inscription: "coveredcreamy stockpileman nakedcreamy waterformer ("nobleform") becoming, nervature/also! mouldnerves! (c'est le chapeau qui fait l'homme) (le style c'est le tailleur)." While the left-hand figure in this picture consists of hat forms closely stuck together, some of them upside-down, the other three figures are held together by cubes and tubes which have been drawn and colourfully painted to fill out the spaces between the hats positioned all over the brochure. The resulting pillar-like figures, which are generally only interrupted by the rims of the hats, all end in a hat themselves. While the second figure has two necks, both with a hat on, the fourth or right figure has been given two legs. At the same time, these tubular creations, which begin at the feet and end at the head, to be interrupted at the joints by hats, so to speak, can also

be regarded as "peripheral nerves," as the word "mouldnerve" would suggest. This picture also gives rise to a wealth of associations which correspond to the ambiguity of the visual images, lending the picture its particular charm and popularity. Here Cubism and its tubes are dismissed as "old hat." It was not in pre-war and post-war literature alone that the hat was regarded as being a sign of bourgeois narrow-mindedness and a quiet life in which security was all-important, for it also became the main objective of Dadaist attacks. By being connected to a system of "communicating tubes," the symbol of a settled and leisurely way of life is exposed to ridicule, similarly to Charlie Chaplin's respectable but outsize clothes. This picture links the distinguishing feature of a man of the world to the psychoanalytical symbol of the sexual organs and equates family trees to textbook illustrations of the sexes; the history of mankind's development from plant life becomes the history of modern mass society ("stockpileman"), progressing from one form of hat to the other, etc.

"On a rainy day in Cologne a teaching aid catalogue caught my attention. I saw advertisements for all kinds of models – mathematical, geometrical, anthropological, zoological, botanical, anatomical, mineralogical and paleontological – all elements of such a differing nature that the absurdity of their being gathered together confused my eyes and my mind, calling forth hallucinations which in turn gave the objects represented new and rapidly changing meaning. My 'faculty of sight' was suddenly intensified to such a degree that I saw these newly emerged objects appearing against a new background. All that was needed to capture this effect was a little colour or a few lines, a horizon here, a desert there, a sky, a wooden floor and so on. And so my hallucination was fixed." (Max Ernst)

This passage, sounds like the genesis of a new epoch. For Max Ernst, it was the literary birth of the collage. The picture *The Master's Bedroom, it is Worth Spending a Night in it* (ill. p. 17) can be regarded as an ironical allusion to an old theme in art history, that of the "studio scene."

The Master's Bedroom, it is Worth Spending a Night in it
c. 1920
Collage, gouache and pencil on paper,
16.3 × 22 cm (6½ × 8¾ in.)
Private collection

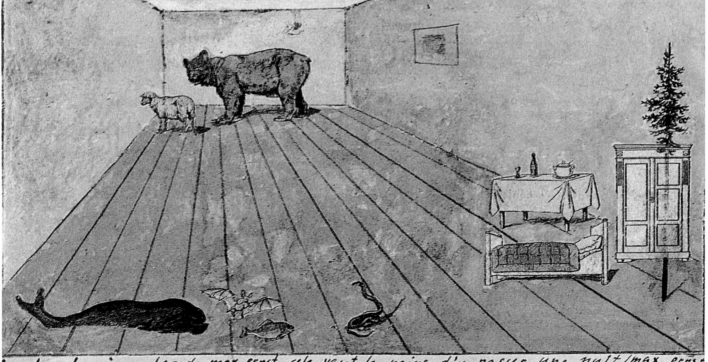

The passage above, which has been taken from Max Ernst's autobiography where it was back-dated to 1919, sounds like a list of instructions on how to produce this picture. The page was originally filled with animals and furniture which were then painted over and reduced in number, leaving the master's favourite animals free, as well as a cupboard, a table and a bed, frugal pieces of furniture suitable for a "craftsman of the spirit." This reduction concentrated attention on the objects left, which were washed over with paint, and dramatized their presence. The fish and the snake are quite clearly sexual symbols. The idea of harmlessness, as represented by the peaceful proximity of the bear and the sheep, is refuted by the risqué touch of the erotic. In his *Interpretation of Dreams*, Freud regarded the laid table as a symbol of women, among other things. The blocked-out surfaces create a strongly foreshortened stage and the scale of both the bear (which is perhaps a self-portrayal of the "master" himself) and the strange furniture gives them a monumental air. In the same way that the sheep and the bear are contradictory, the fir tree with its associations with the idyll of Christmas can be seen as counteracting the symbols of a willingness for erotic adventure.

The Gramineous Bicycle Garnished with Bells the Dappled Fire Damps and the Echinoderms Bending the Spine to Look for Caresses,
1920/21
Gouache, ink and pencil on printed paper on paperboard, 74.3 × 99.7 cm (29⅜ × 39⅜ in.)
New York, The Museum of Modern Art

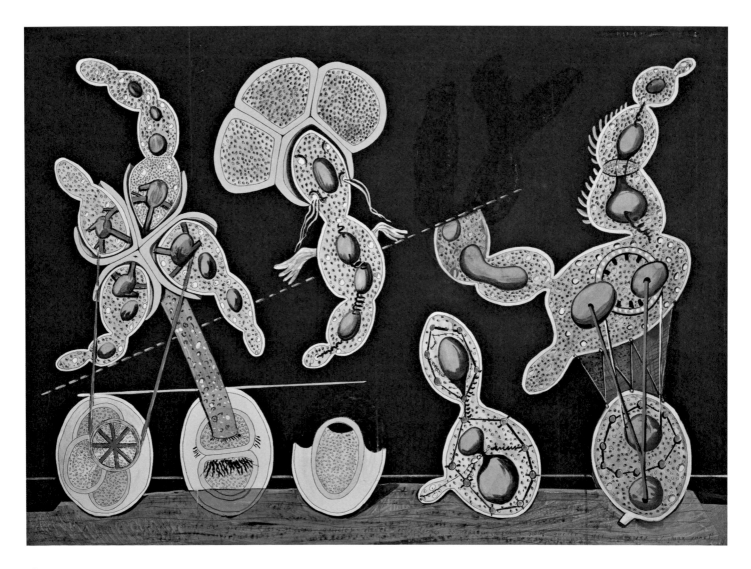

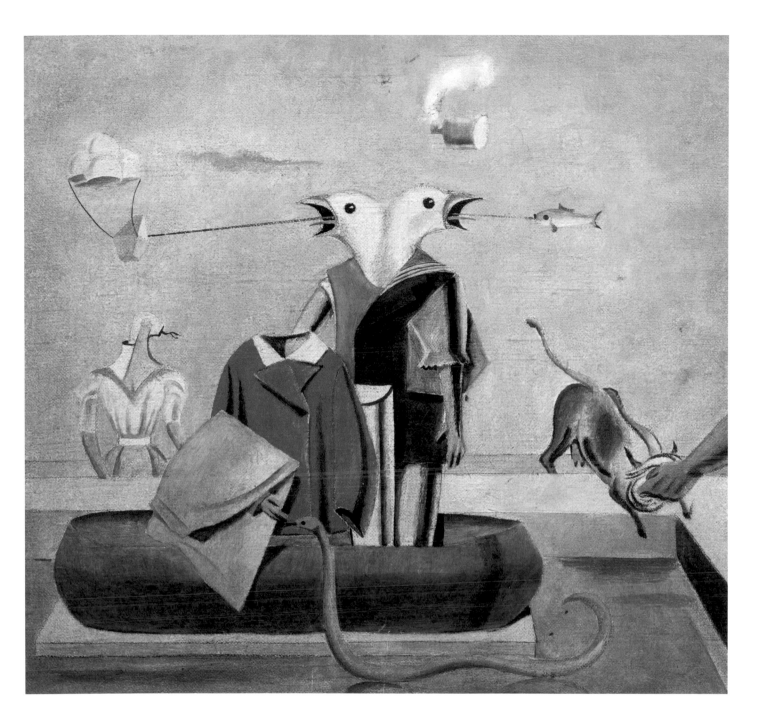

Max Ernst places a Janus-headed birdman on another stage (ill. p. 19). The centre of the oil painting, which is assembled like a collage, resembles a fountain. On its central island, the bird-headed figure stands in a bathtub-like boat. Clad with several costume-like garments the figure is more draped than clothed. Moreover, the artist has placed a sea snake with an outstretched body onto the water surface which is indicated in a condensed manner. The snake is quite curiously darting its tongue in and out, and – almost trustful – it approaches the outstretched right hand. The scene is accompanied by two adjunct figures: another human-like bird creature wearing a light pink dress on the left and a bull whose head is covered by a human hand on the right. The most striking feature, however, is a thread that runs through the two open beaks of the bird and carries a piece of prey – a fish or a bait with a parachute at the

Birds (Birds, Fish-snake and Scarecrow), c. 1921
Oil on canvas,
58 × 62.8 cm (22⅛ × 24¾ in.)
Munich, Pinakothek der Moderne

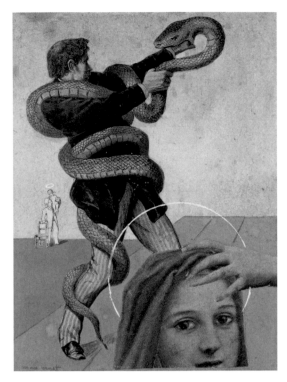

fishhook, so to speak. Max Ernst's use of the motif of bait, which is eaten by several birds, may have been reminiscent of Wilhelm Busch's illustrations for *Max and Moritz: A Story for Seven Boyish Pranks*, where one fishing line kills four birds in one go.

During this early period, Max Ernst also made use of photographs, an important device in the work of the Dadaists. He mainly used this technique to give his collages the appearance of a coherent reality. However, he seldom made use of large pieces of photographs. *Approaching Puberty* (ill. p. 21), which was completed in 1921, is an exception. If this picture is turned on its side, it will be seen that the figure poised in the air was originally that of a nude posing on a sofa. Thanks to the artist's ingenuity, a lying figure is transformed into a hovering one, and a pornographic photograph – which reflected the priggish attitudes of the times – is transformed into a symbol of sheer exuberance and love of life, into a "body catapulted by sensual pleasure." The allusion to the constellation of the Pleiads and the gesture of the arm thrust through the ball, penetrating to the inner realm, emphasizes the fact that gravity has been put out of effect, for although it is able to pull back the stone, it is powerless in the face of the "woman's nakedness."

Max Ernst, who grew up in a petty bourgeois home in the Rhineland during the reign of Kaiser Wilhelm II, experienced art and culture either as an occupation for affluent citizens on Sundays and holidays, or as the dry object of investigation in the hands of art history professors. He rejected both these approaches, breaking loose from the corset formed by the narrow bourgeois view of culture of the time. This in turn led him to a reorientation, a rediscovery of living art. For the present, rejection was the most conspicuous element in his art. His main means of escape was to make use of objects having little to do with art and to employ an absolutely new technique. Mail-order catalogues became metaphors for a world where everything was available. His rows of articles, however unsystematic, reflected the common business practice of putting as many goods onto the market as possible. The organic was replaced by the mechanical and assembly took the place of composition, with the use of collage ousting the skill of the craftsman. He drew with a ruler and dividers, something children are still not allowed to do in their art lessons. The young student was interested in obscure fields of study and had a predilection for all kinds of strange, offbeat topics. His attempt to break away, which was mainly made possible by his use of chance and the unconscious, was a successful one. He had now made room to build up a world of his own and, when he departed for Paris in 1922, he was well-prepared.

Untitled, c. 1920
Collage, gouache and pencil
on paper, 23.4 × 17.7 cm
(9¼ × 7 in.)
Private collection

*Approaching Puberty
(The Pleiads),* 1921
Collage, gouache and
oil on paper on cardboard,
24.5 × 16.5 cm (9¾ × 6½ in.)
Private collection

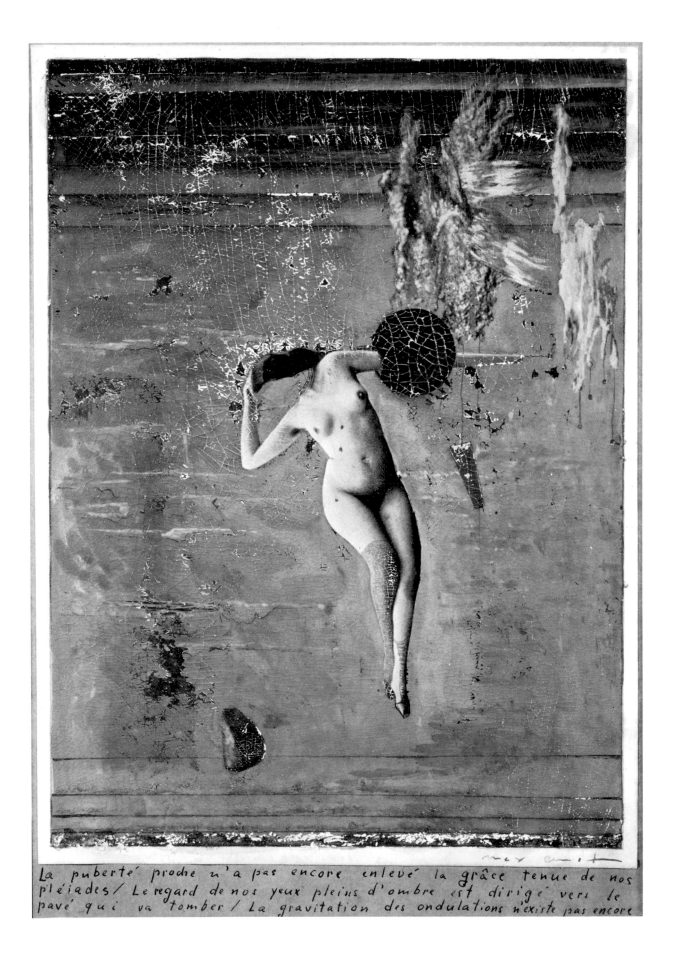

La puberté proche n'a pas encore enlevé la grâce tenue de nos
pléiades / Le regard de nos yeux pleins d'ombre est dirigé vers le
pavé qui va tomber / La gravitation des ondulations n'existe pas encore

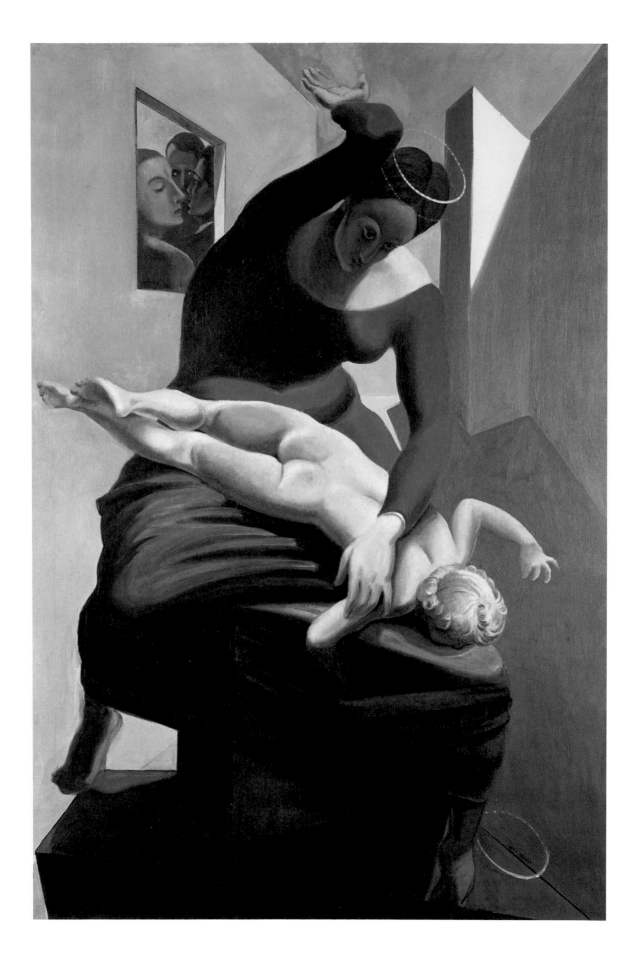

The Magic of Slight Changes
1922–1929

Following an invitation extended to him by his friends Paul and Gala Éluard, Tristan Tzara, André Breton and others, Max Ernst finally left for Paris in 1922, spurred on by difficulties he was experiencing in Cologne. In the same year, he immortalized himself and his friends in a picture based on the old motif of the group portrait, *The Rendezvous of Friends* (ill. pp. 28/29), where they are to be seen gesturing in the sign-language of the deaf and dumb. The new quality of his work, which had gone through a long period of preparation, taking on more and more form, was now able to develop fully. His escape from accepted theories of art had brought about the creation of a new form language of his own.

Apart from *Celebes* (ill. p. 27), which was painted in Cologne in 1921, *Oedipus Rex* (ill. p. 26) is one of the first paintings in which the artist was able to successfully transfer the techniques of combination, assemblage and collage to large scale painting. However, because the initial context of the picture is only recognizable in mutilated or altered form, the spatial situation remains unclear. Here objects differing in scale are arranged in a setting indicated by architectonic elements. A device for marking chicks is pierced through a hand extended through a window and through the nut it is holding. The nut, which has been cracked open, resembles an eye, bringing to mind Luis Buñuel's film *Un Chien andalou*, which was made in 1929. Two birds are to be seen looking out of a hole in the stage in the foreground, prevented from withdrawing their heads by palings and a length of string (or a halter) tied to the horns of one of them. In this picture, the desire for forbidden fruit (indicated by the hand which has reached for the nut) and curiosity (for the birds have put their heads through the opening in order to see something) are immediately punished. There are numerous allusions to the Oedipus legend of classical antiquity, a myth which has retained its validity throughout the history of mankind, for the motifs of vision, blindness and piercing are all present. The picture is given the impression of a collage by the use of hard outlines and the dry appearance of the paint.

In addition to the collages made of non-art materials which had helped him sever his ties to accepted theories of art, Max Ernst began to produce fastidious oil paintings of an impressive size in Paris, based on classical, academic themes in which mythological and historical incidents were depicted. The term "alienation" can be correctly used to indicate the way in which the artist approached this new choice of subject matter, but nonetheless it must be explained a little closer. Like a magician, Max Ernst the artist transformed whatever he touched, whether sacred or profane, and in the same way that magicians conceal their aids, he too concealed the source of the images he made use of in his paintings.

The picture *Teetering Woman (An Equivocal Woman)* (ill. p. 2), is both a hidden allusion to a classical motif, namely that of the goddess Fortuna, as well as a portrayal of "occasio," the

The Blessed Virgin Chastises the Infant Jesus Before Three Witnesses: André Breton, Paul Éluard and the Artist, 1926
Oil on canvas, 196 × 130 cm
(77¼ × 51¼ in.)
Cologne, Museum Ludwig

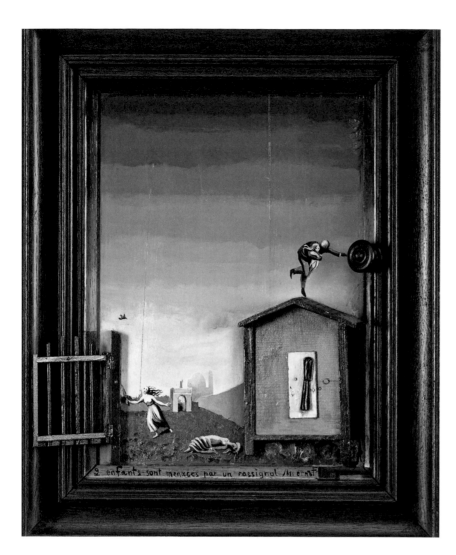

Two Children are Threatened by a Nightingale, 1924
Oil with painted wood elements and cut-and-pasted printed paper on wood with wood frame,
69,8 × 57,1 × 11,4 cm
(27½ × 22½ in. × 4½ in.)
New York, The Museum of Modern Art

At the First Clear Word, 1923
Oil on plaster on canvas, 232 × 167 cm (91⅜ × 65¾ in.) (Mural from Paul Éluard's house in Eaubonne, later transferred to canvas) Düsseldorf, Kunstsammlung Nordrhein-Westfalen

happy moment. Here a female figure of uncertain identity appears on a stage (reminiscent again of de Chirico) which opens up at the back to the sea and a dull grey sky. The woman's arms, which are stretched out as if in balance, form a diagonal axis which fills out the space between the two pillars made of smoothly rounded drums. The pillars, which generally represent the power of the state, form a setting which appears to be none too stable. Moreover, because they are upright, they increase the impression of swaying in the blind and stiffly-jointed doll-like figure of Fortuna.

One of her legs is caught in a strange piece of machinery designed for smoothing the waves of a rough sea, which Max Ernst found illustrated in a French magazine of the late 19th century, a period that was fascinated by all kinds of machinery. In his rendering, the oil which originally spouted out of the holes in this piece of machinery becomes a series of iron bars, meaning danger and captivation. The open mouth can be thus interpreted as a cry of fear. The dancer is based on the figure of a trapeze artist, who hung upside-down in a special circus act with the help of suckers on her shoes, her hair hanging below her. Turned around, it is seen to literally "stand on end." Werner Schmalenbach has pointed out that the typical elements of a Surrealistic work of art, "the fantastic, the dream-like, somnabulism and sadism," are united in this painting, which shows a dramatic scene but presents it in a gentle, classically balanced style. An uncanny event is taking place in the serenest of settings. The goddess Fortuna, caught up in the toils of an incomprehensible machine, makes her appearance between the pillars of power, to vanish again before our very eyes into the dark wastes beyond the stage, leaving nothing but a stone behind.

In 1923 and 1924, Max Ernst spent several months in the house of Paul Éluard (1895–1952), the poet, Dadaist and Surrealist at Eaubonne, north of Paris. In thanks for this hospitality he painted a cycle of pictures in all the rooms of the house, incorporating the walls, the doors and the stucco. When the house was renovated in 1967, one of the most important series of murals in the history of modern painting was discovered under layers of paint and wallpaper. One of the murals, *At the First Clear Word* (ill. p. 25) (based on a line from a poem by Éluard), was detached from the wall and applied to canvas in a method used for restoring frescoes. It was originally part of a room painted in the illusionist style of Pompeian murals; the architecture and garden landscapes, walls and plants were all transferred to an Italian setting. Like the murals painted in villas designed by Andrea Palladio, the four walls of the room were given a blue sky which created the illusion of an outdoors paradise.

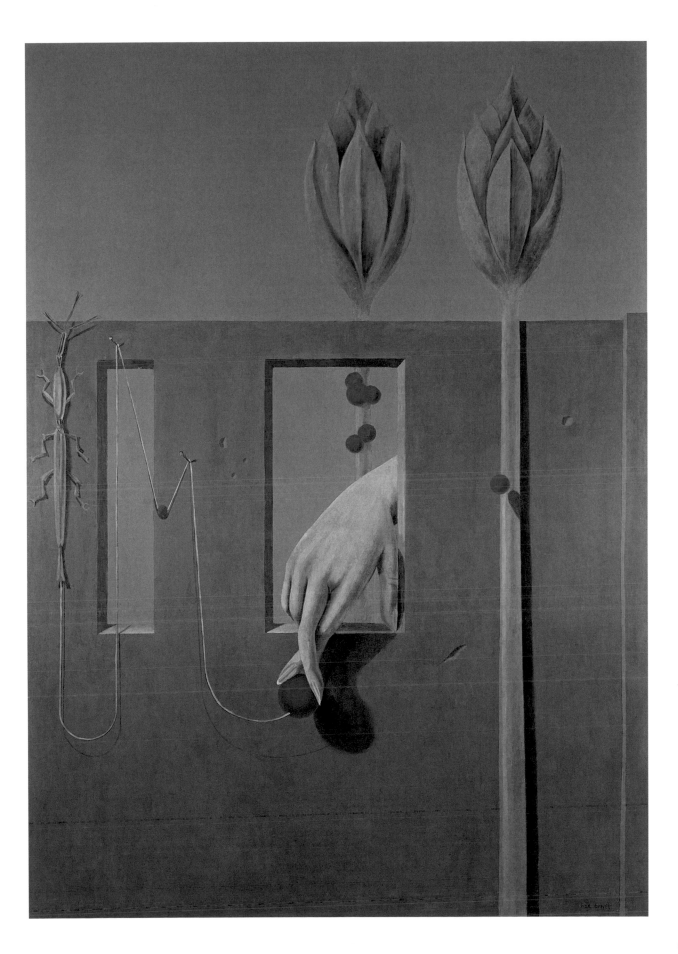

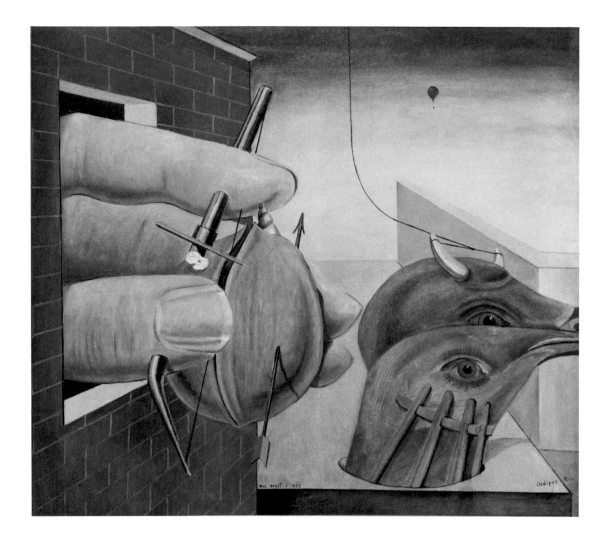

Oedipus Rex, 1922
Oil on canvas, 93 × 102 cm
(36⅝ × 40¼ in.)
Private collection

Celebes, 1921
Oil on canvas, 125.4 × 107.9 cm
(49⅜ × 42½ in.)
London, Tate Modern

In contrast to the Venetian villas of the 16th century, however, the Surrealistic paradise in Eaubonne had its barbs, for freedom and captivity are to be seen in close proximity. Here interior and exterior, plants and architecture, man and animal, are enmeshed in an almost compulsive manner. Throughout the whole of Max Ernst's work, hands play an important part. For the deaf, they are the main means of communication and since his father was a teacher of the deaf, Max Ernst was confronted with sign language from an early age. Moreover, they are also a central and recurrent motif in all kinds of widely-used public directions and instructions. They play a role of outstanding importance throughout the Eaubonne cycle. As in *Oedipus Rex,* a hand reaches through a window-like opening in the wall, holding onto something and thus both showing it and imprisoning it. Like the nut in *Oedipus Rex,* the object being held here by a female hand is a kind of fruit. The picture will be easier to interpret if a closer look is taken at the hand, for it will be seen that the crossed fingers resemble a pair of naked legs, holding a red, cherry-like ball attached to a piece of string between their fingertips (or ankles). The string, which is draped over two nails in such a way that an "M" (for Max) is formed, is attached in turn to a stick insect which is trying to climb over the wall. The ball is not held very securely by the fingers, and were they to let it fall, it would drag the grasshopper down with it into the depths. Even without exact knowledge of the symbols involved, we can soon see that dangerous sexual play is the subject of the picture.

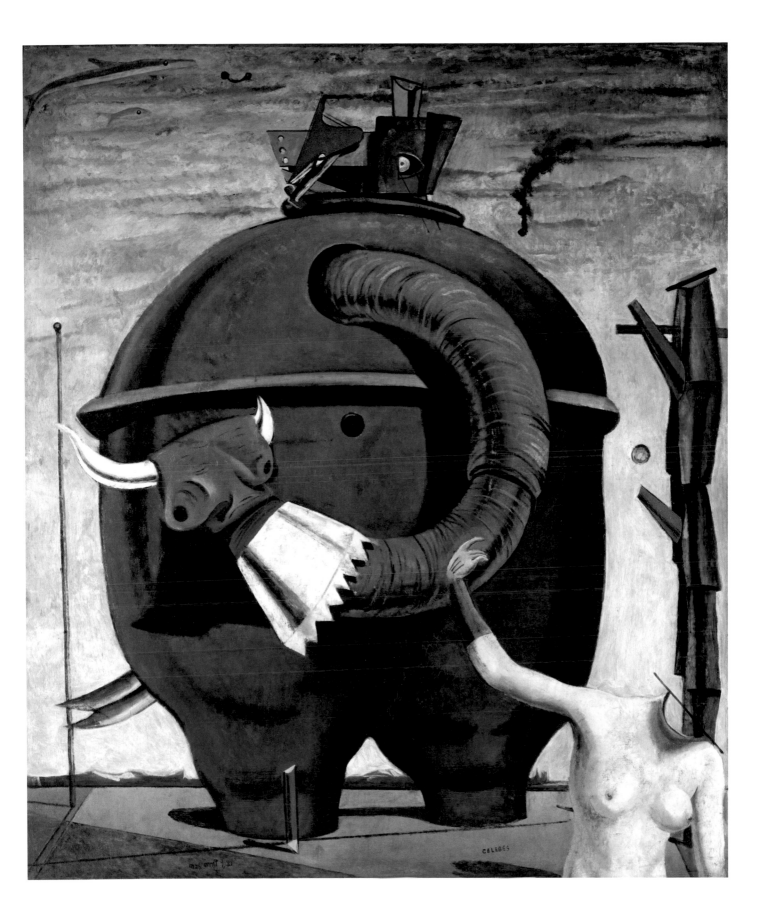

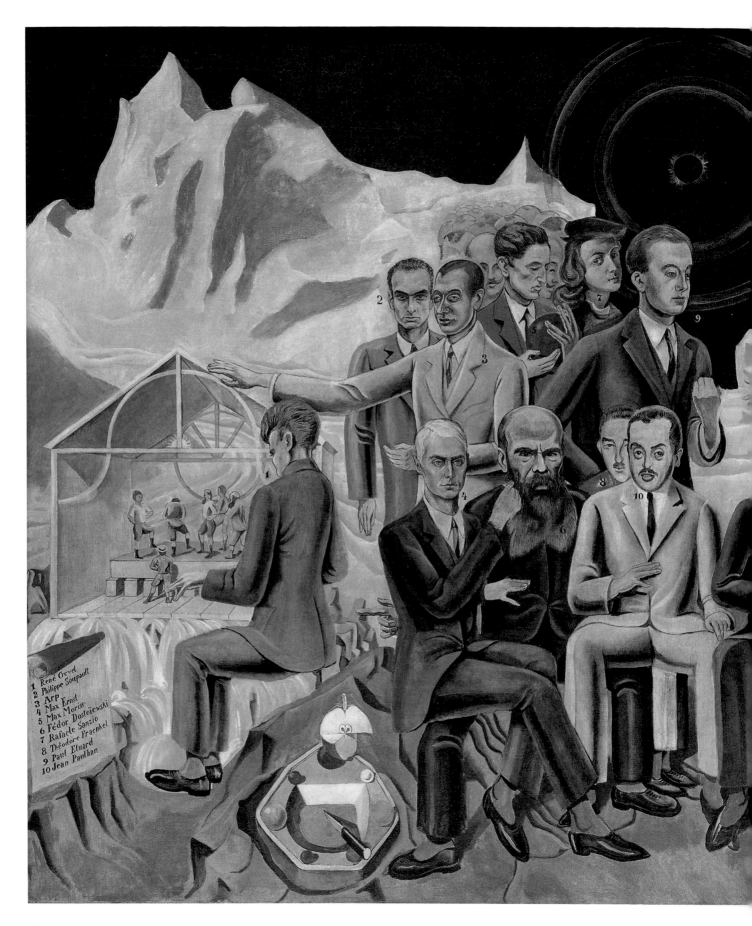

1 René Crevel
2 Philippe Soupault
3 Arp
4 Max Ernst
5 Max Morise
6 Fédor Dostoiewski
7 Rafaele Sanzio
8 Théodore Fraenkel
9 Paul Eluard
10 Jean Paulhan

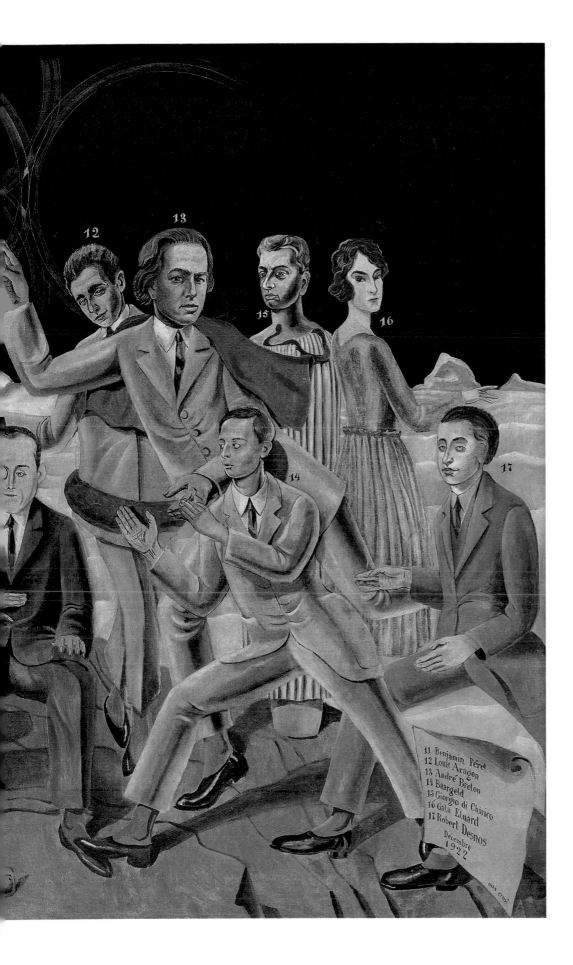

11 Benjamin Péret
12 Louis Aragon
13 André Breton
14 Baargeld
15 Giorgio di Chirico
16 Gala Éluard
17 Robert Desnos
Décembre
1922

The Rendezvous of Friends,
1922
Oil on canvas,
130 × 195 cm (51¼ × 76⅞ in.)
Cologne, Museum Ludwig

From left to right, front row:
René Crevel, Max Ernst
(sitting on Dostoyevsky's leg),
Theodor Fraenkel, Jean
Paulhan, Benjamin Péret,
Johannes Theodor Baargeld,
Robert Desnos; back row:
Philippe Soupault, Hans Arp,
Max Morise, Raffaele Sanzio,
Paul Éluard, Louis Aragon
(with laurel wreath around his
hips), André Breton, Giorgio
de Chirico, Gala Éluard.

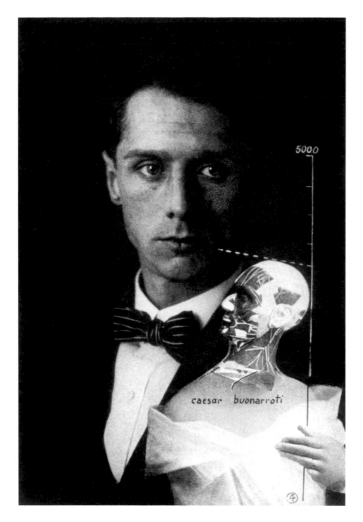

In the same year that this picture was painted, Max Ernst also produced *Ubu Imperator* (ill. p. 31). Illustrations of foundry moulds for bronze equestrian statues formed the most important source of inspiration for this picture. The earthenware mould of the "Ubu" stands on a cone which ends in a steel tip, similar to that of a double bass. The playful but menacing "Ubu," who is presiding over a desert, is clothed from top to bottom in an earthen suit of armour. Next to him a sickle with an exceptionally long handle represents a sceptre or symbol of sovereignity, which he can use to intimidate or even behead his adversaries should it become necessary. A wild mane of hair finds its way through the armour and together with a green piece of cloth, forms the sole personal adornment of this corpulent, monster whom we cannot actually see. *Ubu Imperator* is the superlative of *Ubu Roi*, the title of a play written by Alfred Jarry (1873–1907) which caused a scandal when it was produced and had a decisive effect on the development of modern theatre.

Max Ernst's reference to this play not only reflects the effect it had on Paris artists of the time, it also enlarges on a childhood experience, when his father circled a pot of insects and worms above his bed. The result is a "parody of the traditional way of portraying rulers" (Stefanie Poley). The illustration from which Max Ernst took the idea for this picture gave rise to this very association, for the foundry moulds of equestrian statues have very little to do with aristocratic behaviour.

Max Ernst undertook a journey to the Far East, where he joined his friends Paul and Gala Éluard in Saigon, but first he painted *Woman, Old Man and Flower* (ill. p. 35), which is now in The Museum of Modern Art in New York. In the choice of subject matter and theme, this picture is very similar to *Ubu Imperator*. Something incomprehensible is taking place in a desert-like landscape bordering on a body of water which vanishes into an imponderable distance. The strata that make up this inhospitable landscape are to be found again in a sky partially streaked with clouds. At the time this picture was painted, Breton, Éluard and Max Ernst used to gather together with a group of friends in the evenings (saison des saummeils) to tell each other their dreams and help release unconscious or suppressed thoughts. *Woman, Old Man and Flower*, which was painted over an earlier version, is based on a dream Max Ernst had as a child. In the first version, his father was clearly to be recognized in the figure of an "old man" leaning against a wooden wall to the left. In the second version, the old man was given a wild-looking head with closed eyes in an apelike face. He now had oversized hands but no feet and his body consisted of a broken bowl and his legs of pipes. On the other side of the wooden board a huge, partially transparent female figure with naked lower quarters is to be seen standing in the foreground. She is wearing a fan on her head, an repetition of a motif from earlier pictures. A spinning-top which was part of the original picture is missing in the overpainted version, but the figure of a naked woman has been included again, now lying in the form of a doll in the arms of the "old man," perhaps in allusion to the motif of the "apeman and the white woman" (King Kong).

The Punching Ball or The Immortality of Buonarroti or Max Ernst and Caesar Buonarroti, 1920
Collage, photograph and gouache on paper,
17.6 × 11.5 cm (7 × 4⅝ in.)
Private collection

Ubu Imperator, 1923
Oil on canvas, 81 × 65 cm
(32 × 25⅝ in.)
Paris, Centre national d'art et de culture Georges-Pompidou

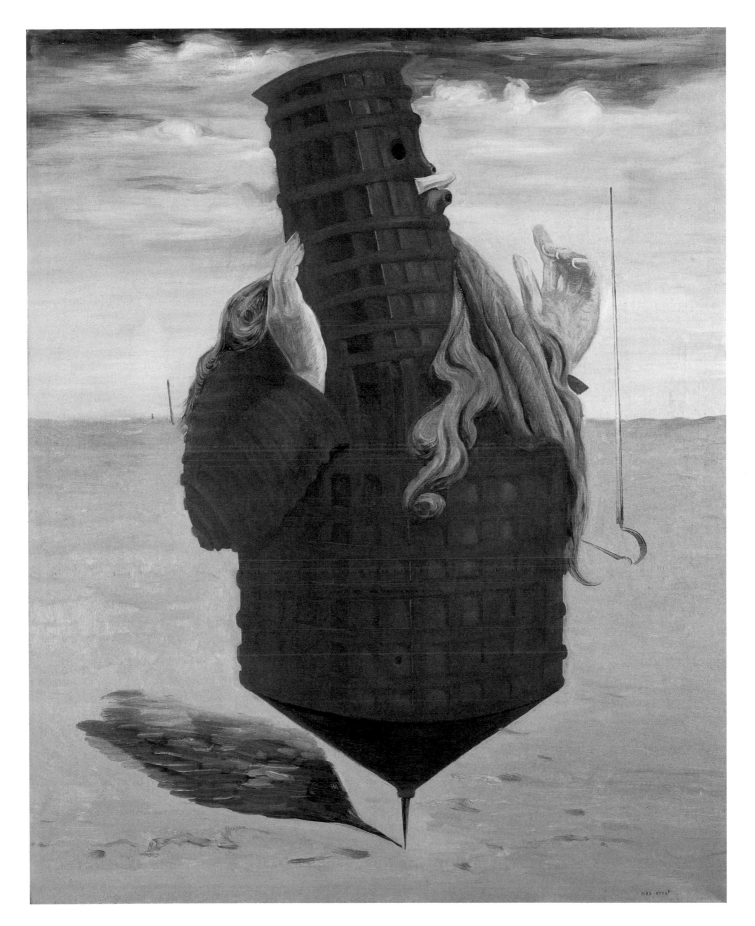

The relief-like painting *Two Children are Threatened by a Nightingale* (ill. p. 24), which was produced in 1924 with the title painted on the inner frame, also makes use of a dream-like landscape to depict a certain condition or state. The incorporation of the real little door, which is comparable to the gate of a homemade bird-cage, causes a shift in the levels of reality along with the would-be architecture formed by the elaborate framework and the wooden handle. The "nightingale," which has been painted above the wooden posts of the gate, can be clearly localized, yet its presence confuses the beholder since the behaviour of the children in reaction to its appearance is incomprehensible. It is the menace of something intangible and inconceivable, of something that cannot be located at any one spot which is responsible for the sense of terror and fear in this picture.

It was shortly after this that the frottage was "invented." Under the heading "Au-delà de la peinture," Max Ernst recounted the birth of the frottage technique in his autobiography in a mythlike way: "On 10 August, 1925, I was able to put Leonardo's teaching into effect with the help of an intolerable vision. It all began with a memory from my childhood, when my bed used to stand opposite panels of imitation mahogany. When I was half-asleep, these panels would act as a kind of optical 'provocateur' and conjure up visions. I was staying at a small hotel at the seaside and it was a rainy night. While I was thinking back to my childhood, a vision befell me, forcing me to look at the floorboards full of marks and scratches in utter fascination. I decided to delve deeper into the symbolic content of this vision. In order to encourage my meditative and hallucinatory powers, I made a series of drawings from the floorboards by laying pieces of paper over them quite by chance and then rubbing them with a black pencil. When I looked at the resulting drawings, with their 'dark parts and others of a clear but subdued dimness,' I was surprised by both a sudden increase in my visionary faculties and by the hallucinatory succession of contradictory and superimposed images which had the intensity and suddenness characteristic of memories of an earlier love. This aroused my curiosity and in amazement, I began to experiment, carefree, yet full of hope. I made use of every kind of material within sight: the veins of leaves, the rough edges of a piece of linen, the brushstrokes of a 'modern' painting, a piece of loose thread, etc. Human heads appeared

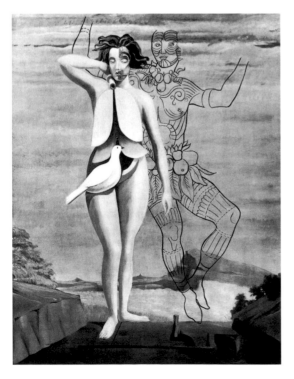

The Fair Gardener, 1923
Oil on canvas, 196 × 114 cm
(77¼ × 45 in.)
Formely Düsseldorf,
Kunstmuseum (confiscated
in 1937 and since missing)

before my astonished eyes and animals too, a battle ending in a kiss (the bride of the wind), rocks, the sea and rain, earthquakes, the sphinx in its stable, little panels round the earth, Caesar's palette, wrong positions, a fabric of frost flowers, the pampas, whip lashes and trickles of lava, fields of honour, floods and seismic plants, fans, a toppling chestnut tree, ... flashes of inspiration before fourteen, injected bread, pairs of diamonds, the cuckoo, the origin of the pendulum, death's feast, the wheel of light. A system of sun gold. The robing of the leaves, the fascinating cypress. Eva, the only one left. The first results of the frottage (rubbing) were gathered together under the heading of natural history."

What Max Ernst has described here in the form of a story of creation can help towards a better understanding of the *Histoire Naturelle*. Before we turn any closer to this *pièce de résistance* of frottage and with it to the art of Max Ernst, let us comment on this quotation for a brief moment. Surrealism was fundamentally a literary movement, its central manifesto, which was published in 1924, being written by André Breton. The works of writers such as Marcel Proust, Arthur Rimbaud, Stéphane Mallarmé, Guillaume Apollinaire, Pierre Reverdy and many others were very much present in the Surrealist group. Max Ernst's

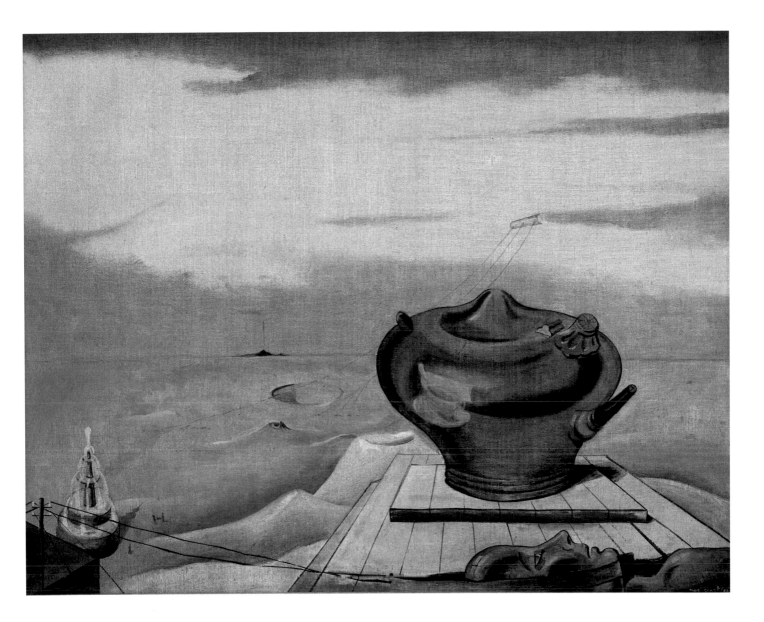

"panels of imitation mahogany opposite (his) bed," which revealed a world of visual apparitions, is reminiscent of the "Madeleine" biscuits mentioned in Proust's novel *À la recherche du temps perdu*, where the taste of these biscuits releases a flood of memories. In a similar way, the grain of the wood panelling opened up to Max Ernst a world of optical apparitions which had previously been hidden behind the wall of rational thought. In order to fully understand Ernst's description of how *Natural History* came into being, it is also necessary to explain what he meant by "Leonardo's teaching." In his treatise on painting, Leonardo da Vinci commented on the beauty of "spots on the wall," remarking that "if you look at them carefully enough, you will make some wonderful discoveries." The Surrealists above all used to quote these statements in defence of their work, as well as subsequent artists such as Wols and Antoni Tàpies and other painters, up to the present day.

What distinguishes the 34 drawings of the *Histoire Naturelle* series from earlier rubbings and the collages in particular is the freedom of interpretation they entail. The images used for the work of the earlier period had such a strong language of their own that it generally remained visible, or legible, after they had been assembled to form a new picture. This in turn

Seascape, 1921
Oil on canvas, 66 × 81 cm
(26 × 32 in.)
Private collection

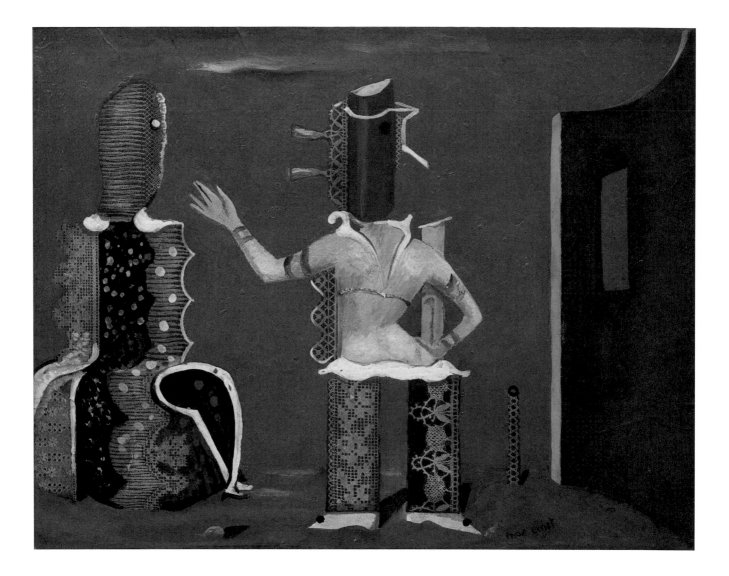

The Couple (*The Couple
in Lace*), 1923
Oil on canvas,
106.5 × 142 cm (42 × 56 in.)
Rotterdam, Museum
Boijmans Van Beuningen

meant that they could only give rise to a somewhat limited range of associations, restricting the meaning that the picture could take on. However, freedom of interpretation does not necessarily imply arbitrariness. It would be a great mistake to believe that Max Ernst achieved his grains or structures by rubbing over objects chosen at random. It may be true that he wrote of placing pieces of paper over certain areas quite "by chance," but it was a chance that was consciously guided. If one regards the phototype prints of these drawings individually, it will be noticed that the rubbed objects were all extremely simple in structure. At the same time, these frottages are characterized by a very simple, but strict form of composition. Every one of the twelve oblong prints has a landscape or stage indicated by horizontal parallel lines. The subjects of these drawings, which are not always easy to identify, are squarely positioned against the background, as in the case of the eye and the horse (ill. pp. 38, 41), and consist of structures and grains totally flexible in use. The 22 upright prints also have a strictly axial composition. Here an almost geometrical world is brought into being by the simplest of means, namely the interplay of rubbed-through structures (such as the veins of leaves and the grain of wood) with the resulting forms, such as a leaf pressed in between two walls as in *Les mœurs des feuilles (Leaf Customs)* (ill. p. 41). The magic and diversity of this series is to be explained by the artist's absorption with the twisted paths of grain and texture

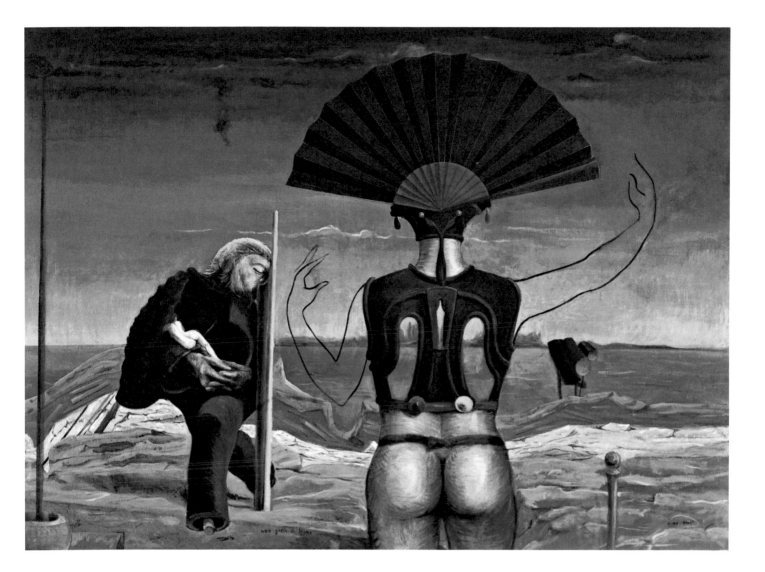

and in the alternation of views seen from the above and the side, as well as in the choice of a spatial treatment using perspective and flat, two-dimensional ones, and in the alternation of close-up views and portrayals from farther away. The title of the series, *Histoire Naturelle*, helps decipher a further dimension of meaning. Natural history is the observation and study of all organic and non-organic life, including the animal, vegetable and mineral worlds. With this series, Max Ernst took up the belief in natural history, which found its culmination in the positivism of natural science, and confronted it with a style of representation which embodied the realms of dreams, sleep and the imagination. Starting with the painstakingly exact way plants had been drawn from the middle of the 19th century, Max Ernst developed a method with the help of his "art of disarrangement" (namely that of the frottage) to find a way out of the constrictive and copyist methods used in these plant drawings, thus escaping from the rules laid down by current theories of art. In this respect, frottage was more than just another technique, it was an artistic procedure which broke new ground with regard to both concept and subject matter.

Werner Spies has drawn attention to the fact that at the time the photographs of Karl Blossfeldt (1865–1932) were also concerned with strange forms of buds and blossoms. His plant books *Urformen der Kunst* (1928) and *Wundergarten der Natur* (1932) displayed a similar

Woman, Old Man and Flower, 1924
Oil on canvas,
96.5 × 130.2 cm (38 × 51³⁄₈ in.)
New York, The Museum
of Modern Art

love of the unusual in the areas of nature and technology. However, the strange way in which Max Ernst "disarranged" things distinguishes his work from the photographs of Karl Blossfeldt and it is here that his artistic manipulation of the visible world becomes most clearly recognizable.

One of the most beautiful drawings from the *Histoire Naturelle* series is the final one, that of *Eve, the Only One Left to Us* (ill. p. 38). For Max Ernst the artist, natural history culminated in the figure of a woman. As a whole, the series can also be seen as an allusion to the story of Creation. At the beginning, there were heaven and earth, both desolate and empty. Then followed the stars, and grass, herbs, trees and other forms of plant life came into being. Finally, living beings emerged: fishes, reptiles and animals (represented by horses in this series) with Eve in conclusion. Here Eve has turned her back on the beholder, but she cannot prevent us from reading all kinds of fantasies and ideas into her. The importance this final picture had for the artist can be seen in the fact that several different versions of it were made in oil and plaster, with one of them showing the motif of the neck and the bobbed hairdo twice (ill. p. 39). The great difference between the frottage and this oil and plaster version is the elongation of the neck in the latter and the distinctly modelled cervical vertebrae. In order to give the hair a similar structure to the frottage version, it was scraped out of a compound of plaster and oil, a method which was not only to become a decisive characteristic of Max Ernst's "painting" during this period but which was also to pave the way for grattage.

Grattage (or, roughly translated, scraping) is a transferral of frottage to the medium of painting. The artist's dislike of the traditional approach to art, with the necessity for an academic way of drawing and an application of colour in accordance with the methods of the Old Masters, has already been mentioned. His search for technical means of avoiding a direct application of paint runs throughout his entire work, as do his efforts to carry out the picture itself and its subject with elements non-related to art. The strangeness of such elements and the wealth of interpretations and associations that could be read into them was an additional quality which warranted his use of materials laid beneath the canvas. In addition to the classical grattage technique, in which a layer of paint was scraped away to reveal underlying structures, the artist also changed the surface of his work in a variety of other ways

The Sun Wheel, 1926
Oil on canvas,
144 × 112 cm (56¾ × 44 in.)
Private collection

Le fagot harmonieux, 1922
Illustration to *Les malheurs des immortelles* by Paul Éluard
Collage
Private collection

Paris Dream, 1925
Oil on canvas, 64.8 × 54 cm
(25⅝ × 21⅜ in.)
New Haven, Yale University Art Gallery, Gift of Katherine S. Dreier

from 1925 on. In *Paris Dream* (ill. p. 37), which was produced in 1925, he used a wire comb to scrape two-thirds of a circle into the final surface of beige-grey paint, revealing a layer of blue below. The celestial body thus formed is poised above the three gables of a row of houses or portals, which appear to be built of red strips of rock in an organic-looking pattern. Above the petrified city a tropical sky emerges from the haze. The confrontation of culture and vegetation, civilization and the tropics was increasingly being emphasized in the artist's work. *Sunwheel* (ill. p. 36), can be seen as a magnificent version of the style that had taken on shape in *Histoire Naturelle*. Here two mighty celestial rings, swallowed up by the blue sky above, reach into water moved by swirls and eddies, in an attempt by the artist to continue the tradition originated by the Romantic artist Caspar David Friedrich (1774–1840) with his cosmic landscapes. The variety of effects that could be brought about by the grattage technique can be recognized in this picture. In the case of the sun circles, the imprint of a tyre or hose can be seen, while the movement of water seems to have been produced by a layer of threads and other, unidentifiable objects. The interrelationship of heaven and earth and the increasingly important role played by the horizon were becoming the distinguishing features of Max Ernst's work, which was gaining more and more in poetical force. The themes of air and water were now joined by those of forests and the city, as anticipated by *Paris-Dream*. A whole series of "forest" pictures came into being, with a series of "fishbone" forests playing a particular role of their own. In the *Fishbone Forest* (ill. p. 43), three shells, themselves mixed beings like the forest itself, are lying at the bottom of a hollow framed on both sides by architectonic enclosures. Again, there is the menace of a celestial body, now suspended in a fire-red sky. The paradisiacal green hollow is hemmed in by the dark-brown enclosures and the fishbones of the grattage, and menaced by the secret ring above.

Eve, the Only One Left to Us, 1925
No. 34 of the *Histoire Naturelle* series
Frottage, pencil on paper,
43.1 × 26.1 cm (17 × 10⅜ in.)

The Wheel of Light, 1925
No. 29 of the *Histoire Naturelle* series
Frottage, pencil on paper,
25 × 42 cm (9⅞ × 16⅝ in.)

Eve, the Only One Left to Us, 1925
Oil and plaster on cardboard,
50 × 35 cm (19¾ × 13⅞ in.)
Private collection

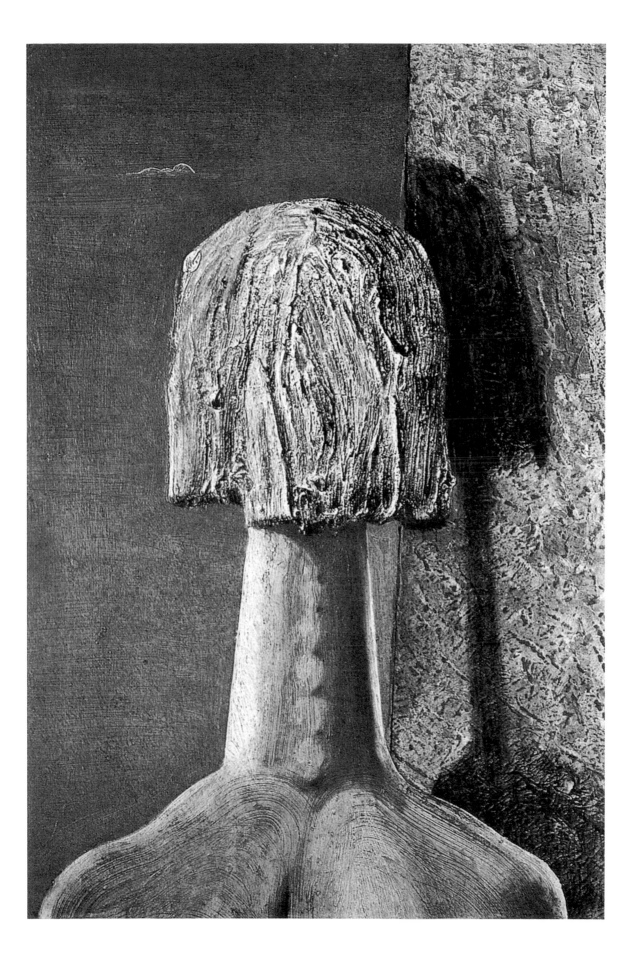

The *Paris Dream* of 1925 took on more concrete form in *Vision, Induced by the Nocturnal Aspect of the Porte St. Denis* (ill. p. 42), which shows how mastery of the grattage technique changed the form of depiction while increasing its possibilities. The title refers to the magnificent but outsized city-gate of the same name in Paris, which had been turned into a triumphal arch. In 1927, when this picture was painted, it had no function whatsoever and it still has none to the present day. As in the Paris of the earlier picture, a city melted to stone, the beholder is confronted with an inaccessible wall. Both this wall and the worn-looking but monumental city gate awaken childhood memories of thickets in woods. Rubbed-through boards, some upright and others leaning at an angle, form an impenetratable barrier. Birds, indicated here by small rings rubbed through the canvas, make their home in a barely visible wheel. The wood has taken on the double role of an inaccessible nature preserve, where civilisation and culture have no entry, and a sanctuary or refuge for the birds.

In the same year, further pictures were produced which were closely related to these "forest" portrayals, for the "wild men" which now came into existence were suitable inhabitants for these forests. *The Horde* (ill. p. 44), dating from 1927, shows a group of these fantasy creatures who seem to be forcing their way out of the right-hand side of the picture ("Oh woe, if they are let loose") in front of a bright-blue background. In contrast to the forest pictures, which were defensive in character, the hordes here fight their way aggressively to the outside. It has been said of them that they had "slept too long in the forest." The winding patterns of lengths of rope, which can be seen in several places against the brown background of the figures, provided the original inspiration for this picture, which is now in Amsterdam. In addition to the "wild man" who dominates the right-hand side of the painting, there are also fictitious creatures with claws, teeth and horns. These horde and forest pictures were Max Ernst's contribution to the art of the Twenties, as exemplified by the work of Beckmann, Dix and Grosz, which shrewdly anticipated the approach of barbarity and fascism.

Dead Man's Repose, 1925
No. 28 of the *Histoire Naturelle* series
Frottage, pencil on paper,
25,8 × 43 cm (10¼ × 17 in.)

In 1927, Max Ernst also produced the large painting *After Us Motherhood* (ill. p. 45). Like the mysterious title, which tends to conceal rather than explain the subject of the picture, the painting technique conceals the incorporation of objects laid below the canvas in the grattage technique. Here birds of differing shape and size are grouped together in the form of a figure. The role they played in the artist's work will be explained at a later point. In this context, the reader is referred to the "Bird Monuments," which were created at this time too. In this picture, the central group, which is a portrayal of a mother and child composed in the manner of Raphael's Madonna paintings, is seated on a baroque pedestal and thus monumentalized. Other birds are flying around the group. The red one is bringing a "message" in its beak, while the large yellow bird with strange human lower quarters is ascending to heaven as a symbol of the "Holy Ghost," thus pointing to the transcendentality of the mother-and-child group. The blue silhouette of another bird, which gives the picture spatial depth, breaks through the level of reality on which the scene is taking place, and opens the picture up. Barely perceptible lines of perspective also contribute towards this effect.

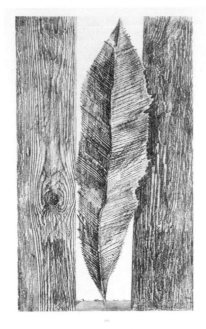

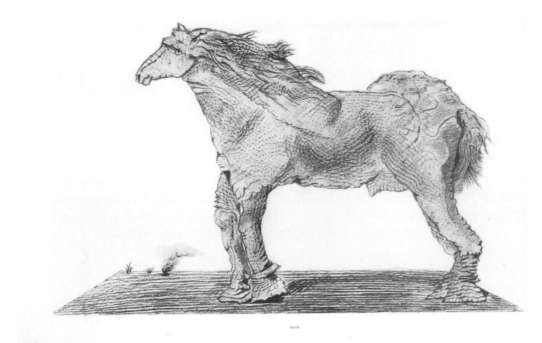

Leaf Customs, 1925
No. 18 of the *Histoire Naturelle* series
Frottage, pencil on paper,
42.7 × 26 cm (16⅞ × 10¼ in.)

The Fascinating Cypress, 1925
No. 17 of the *Histoire Naturelle* series
Frottage, pencil on paper,
42 × 25 cm (16⅝ × 9⅞ in.)

To Forget Hearing and Seeing, 1925
No. 32 of the *Histoire Naturelle* series
Frottage, pencil on paper,
28 × 44.5 cm (11 × 17⅝ in.)

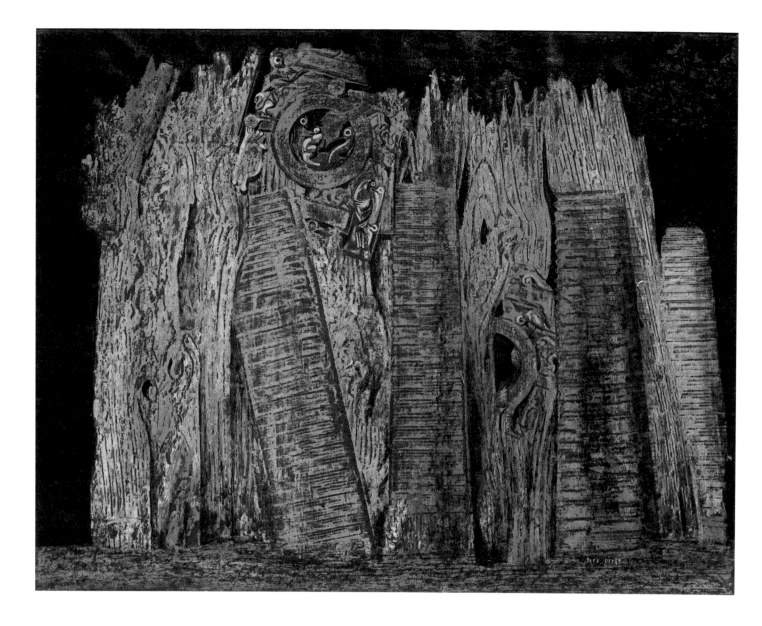

Vision Induced by the Nocturnal Aspect of the Porte St. Denis, 1927
Oil on canvas, 66 × 82 cm
(26 × 32⅜ in.)
Private collection

Once again, Max Ernst was making use of a classical subject to deflate and demask the common Western illusion of the family, which was based on the ideal embodied by the Holy Family or the Madonna, in a humorous and ironical way. He achieved this not only by making conscious use of cultural symbols but also with the artist's method of combining different levels of reality.

As usual, he also played with allusions to tickle the unconscious. Indeed, it was the prevalence of rational systems, under the guise of Christianity and civilisation, that contributed to the eruption of political barbarity in the form of fascism masquerading as humanism. Christianity, heathenism, mythology and desecration are closely interwoven in this picture. *After Us Motherhood* is a reference to a matriarchial form of society, which we have (unfortunately) overcome or which is in the offing. Max Ernst contrasts this loss of security with the joyfulness of children who have begun to leave the family nest.

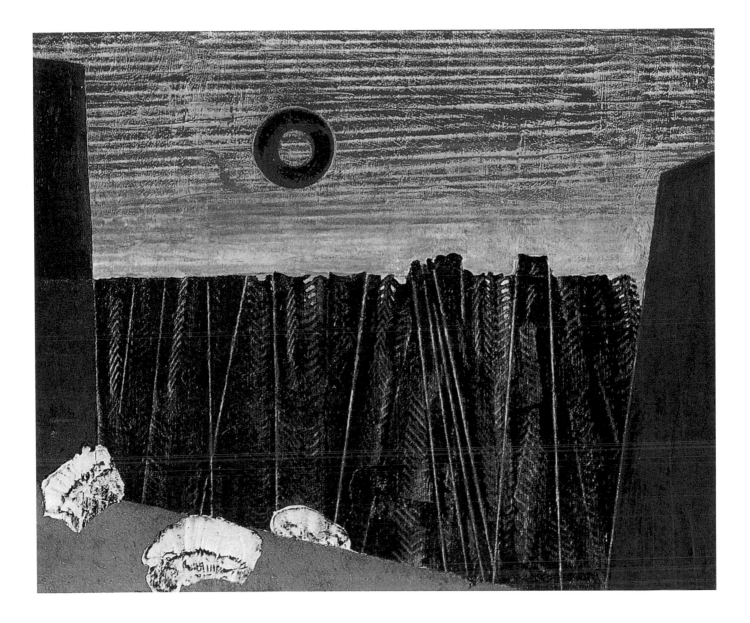

Fishbone Forest, 1927
Oil on canvas, 54 × 65 cm
(21³⁄₈ × 25⁵⁄₈ in.)
Private collection

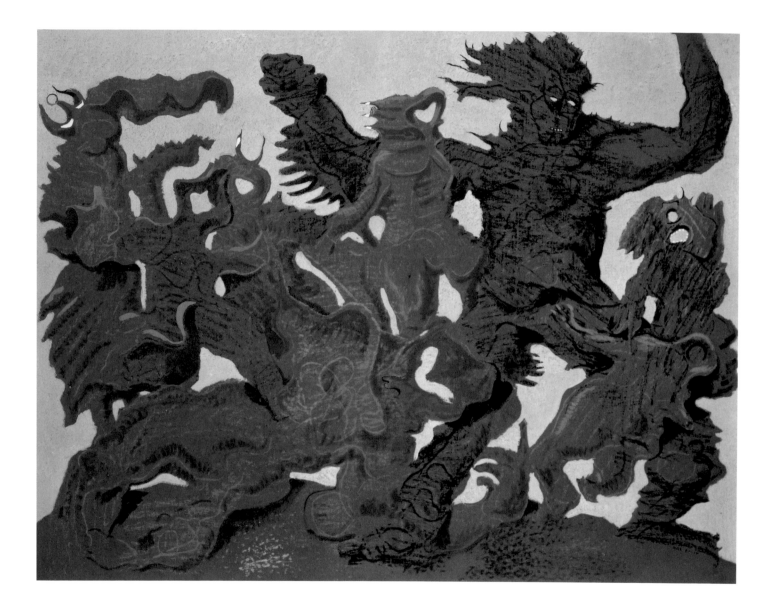

The Horde, 1927
Oil on canvas, 127.5 × 158.5 cm
(50¼ × 62½ in.)
Amsterdam,
Stedelijk Museum

After Us Motherhood, 1927
Oil on canvas, 146 × 114 cm
(57½ × 45 in.)
Düsseldorf, Kunstsammlung
Nordrhein-Westfalen

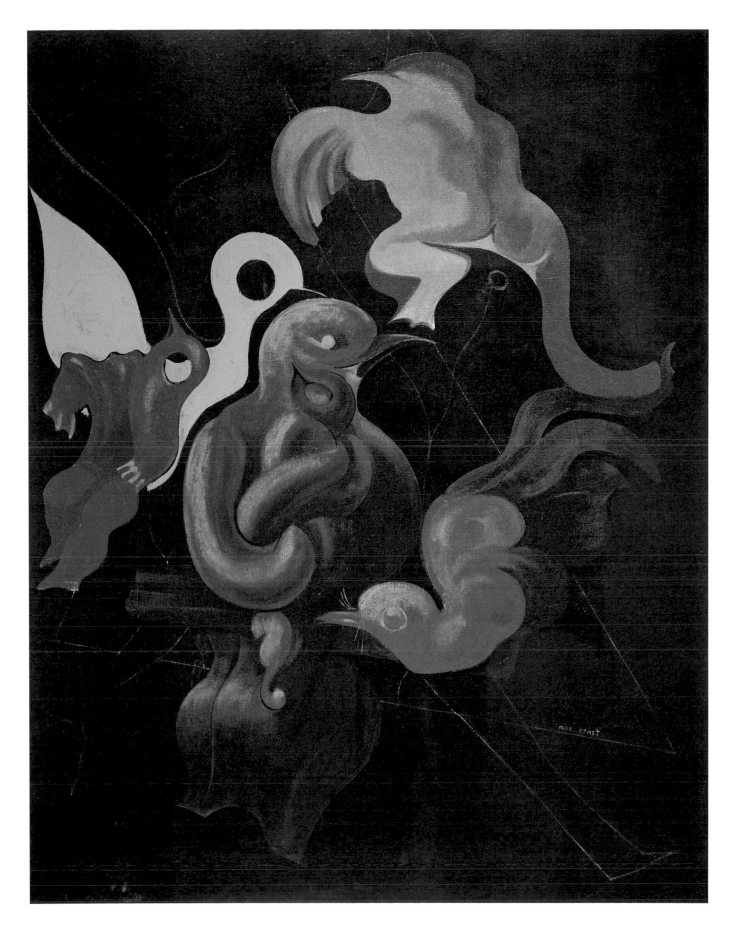

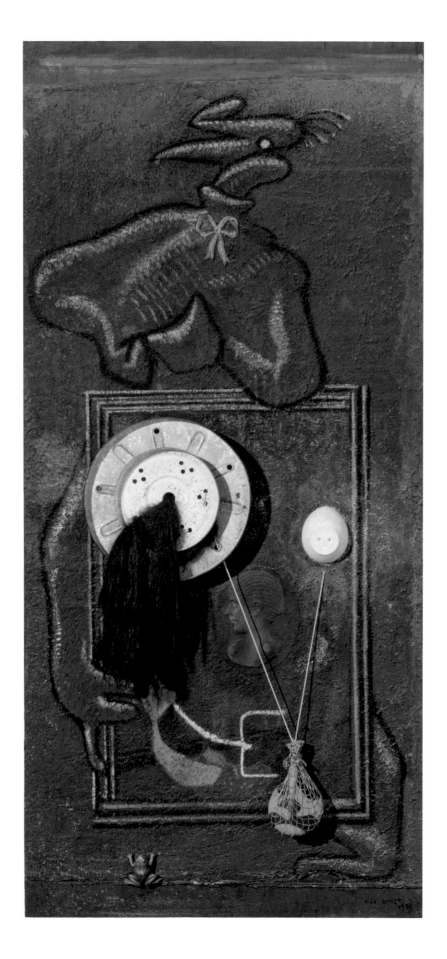

Loplop Presents
1930–1949

In addition to his large-sized pictures done in the collage, frottage and grattage techniques, Max Ernst began producing books of collages in the years between 1929 and 1939, the best-known being *Une Semaine de bonté* and *La Femme 100 têtes* (ill. p. 49). The latter, which set the standard for this kind of Surrealist work, consisted of 147 collages woven into an outlandish whole. More than half of the collages in this book were made of woodcut illustrations taken from story magazines. (In the days of Expressionism and classical Modernism, woodcuts were frequently regarded with disdain.) It was in the captions of these two books that the name of "Loplop" made its appearance for the first time in the artist's work. Here Loplop took on the role of narrator and actor (along with the "Vogelobre Hornebom") as well as that of "enlightener," for in the book it was Loplop who lit the lamps of Paris. Loplop represented the artist himself as his "private phantom," as Max Ernst himself once put it. In short, Loplop was an impresario – presenting...

The name was probably taken from a street poet called Ferdinand Lop, who was very popular in the student quarter of Paris, where he was nicknamed Loplop. In the *Dictionnaire abrégé du Surréalisme*, which was published in 1938, the entry on Max Ernst describes him as being "'The Vogelobre Loplop,' Surrealist painter, poet and theorist from the beginnings of the movement to the present day," making it quite clear that the artist did indeed identify himself with this bird-like creature, using it to appear in his work in person, either in caption or pictorial form.

Artists had begun appearing in their paintings themselves in more or less hidden form since the late Middle Ages, either as passive observers or as active protagonists. The roles they took on as participants in the doings of their times ranged from those of keen observers and witnesses to those of prophets, doers and artists of a new world. The role of the artist as soothsayer and seer gained in significance during the Expressionist period, which preceded Dada and Surrealism.

With this in mind it soon becomes clear that Max Ernst had once again dipped into the treasure-chest of art and pulled out a popular and frequently-used requisite, to make it his own. The result was "Loplop introduces." Before going into what Loplop introduced in detail and determining the significance of this radical new development, let us take a look at one of the first pieces of work to be completed in this series, namely that of *Loplop Introduces Loplop* (ill. p. 48), which was painted in 1930.

Invitation to the "Exposition Max Ernst," Paris 1935

Loplop Introduces a Young Girl, 1930
Oil, plaster and various materials on wood,
194.5 × 89 cm (76⅝ × 35 in.)
Paris, Centre national d'art et de culture Georges-Pompidou

In one of his few roles as a film actor, Max Ernst took part in Buñuel's *L'Âge d'or*, one of the most important Surrealist films to be made, which was published in 1930. In the first part of the film we see a hut made of plywood boards, on which plaster was thrown at to change its appearance. The result, which had all the strangeness of a Surrealist piece of work, looked like a surface primed for painting, and, at the same time, it must have reminded Max Ernst of Leonardo's wall, for he made use of one of these boards, with its surface "applied" by others, to reply with a picture of his own as it were. The middle of this oblong painting is dominated by a mighty, spread-out, hen-like creature, holding a framed board-mounted picture in its three wings with their pointing hands. In repetition of the motif, the little picture contains a portrait of another bird-like creature, spreading out its shell-like wings. The bird-creature Loplop is explaining his existence by directing our attention to a miniaturized picture of himself. Here the artist is portraying himself as a painter, with a third figure, holding its hand open in a gesture of demonstration, posed behind him.

In this way, the artist makes visible something which had previously been unseen, in accordance with a central tenet of modern art. For example, the Expressionists were mainly concerned with making feelings visible, while the Dadaists and Surrealists sought to express the unconscious psychic import underlying the surface of banal, everyday reality. It is therefore not surprising that they made use of "normal" commonplace articles, presenting them with the respect usually reserved for the special and displaying them as if they were cult objects. Indeed, presentation itself soon became the object of Surrealist work, with Raoul Hausmann (1886–1971), who helped found the Dada movement in Berlin, and Kurt Schwitters (1887–1948), who lived in Hanover until he emigrated in 1937, declaring themselves the "Creators of Presentationism" in November 1920.

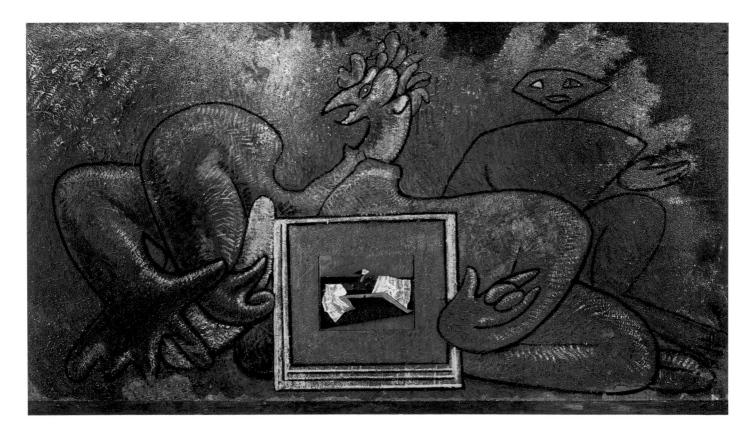

the Song of Songs of the winter holiday-maker, 1929
Plate 49 from the collage-novel *La Femme 100 têtes*
Woodcut collage,
8.3 × 14.7 cm (3⅜ × 5⅞ in.)

Almost at the same time that this key picture of the Loplop series was painted, *Loplop Introduces a Young Girl* (ill. p. 46) was also produced, again inspired by a setting from Buñuel's *L'Âge d'or*. Here a 175 cm high layer of plaster can be seen quite clearly on the plywood board, which is 20 cm longer. The object to be "presented" here is a frame enclosing various objects, such as a bunch of hair, a circular, plate-like object and an oval moon, (perhaps the underside of a flat little bowl). Loplop is pictured here as a tall bird, proudly displaying his booty. Two limbs which act as legs are holding the sides of the picture-frame like tentacles or creepers. In the midddle of the picture there is a medallion of a "young girl," which has been painted over in such a way that it almost disappears in comparison to the other objects, which seem to thrust themselves into the foreground. The plate-like object and the "moon" are linked by a piece of string, from which a net-bag is hung, holding a painted stone (from Maloja?). The "impresario's" neck is embellished by a bow stuck into the plaster. At the bottom of the picture a frog, which was added later, is trying to climb up to the picture-frame. The rough surface of the plaster and the bunch of hair, the plate and the painted stone, held in its net, awaken a wide range of associations which are chanelled into a certain direction by the medallion and the title of the picture. The bird is holding the girl captive in its arms, presenting her to the greedy eyes of the beholder. In this connection, the figure of the frog can be seen as alluding to the fairy-story of the "Frog Prince."

Closely related to this picture in subject, form and technique is the picture *Human Form* (ill. p. 51), a large painting that was completed in 1931. Once again, a setting from Buñuel's *L'Âge d'or* provided the source of inspiration. *Human Form*, which was painted on a rough layer of plaster, belongs to a group of Loplop portrayals based on the form of the human body. At the same time, the outlined shape of this mixed being, which is drawn on a painted layer of rough-looking plaster, includes certain forms and elements which give it its particular character. The lancet-shaped leaves growing from its hips and shoulders are allusions to the plant world, while details of a grasshopper, which can be recognized in the head and the scar-like spine running down the front of the torso, can be seen as references to the animal kingdom.

Loplop Introduces Loplop,
1930
Oil and various materials on wood, 100 × 181 cm
(39⅜ × 71⅜ in.)
Houston, The Menil Collection

Blind Swimmer
(Effect of a Touch), 1934
Oil on canvas, 93 × 77 cm
(36⅝ × 30⅜ in.)
Private collection

Human Form, 1931
Oil and plaster on wood,
183 × 100 cm (72 × 39⅜ in.)
Stockholm, Moderna Museet

When one thinks of African sculptures, such as those shown with Surrealist objects at the famous exhibition held by Charles Ratton, an ethnological dealer, in 1936, the rod reaching from the creature's face to its knees will easily be recognized as a phallic sexual organ being triumphantly displayed by Loplop. (The total composition may well have been inspired by Freud's essay on disquiet in literature, which was published in 1930.) In this picture, plant, human and animal life combine to form the monumental figure of a triumphant guardian of the unconscious. In the guise of the "Archangel Michael," Loplop takes up his stance before the gates to Paradise, the jungle of our longings, feelings and fantasies.

In *The Embalmed Forest* (ill. p. 55), the dotted outline of a fantasy bird-like creature is to be seen flying in the midst of that very jungle of feelings. As has become apparent, birds played a very important role in Max Ernst's work. At the beginning of his autobiography, he clearly identifies himself with them, and his idea of using a "bird" as a symbol of mankind found the immediate acceptance of his friends. In one of his poems, Éluard characterizes him in the following way: "Swallowed up by feathers and left to the seas, he has translated his shadow into flight, into the flight of the birds of freedom," while in another text, written by his friend Jacques Viot, he is described as a bird of prey: "Max Ernst has departed alone for the woods that no hunter has ever seen."

From the early 1920's on, the most commonly used emblematic symbol was the bird, initially in the form of the dove. The dove waiting in front of *The Fair Gardener's womb* (ill. p. 32), for example, is quite clearly a symbol. (The Nazis considered this picture an abomination and included it in their exhibition of degenerate art before seeing to it that it disappeared forever.) The motif of the tamed dove, imprisoned in a cage, was a frequent one in Max Ernst's work and it was not to be superseded until the appearance of Loplop, the bird-like creature who moved about the world with the freedom of the artist and impresario.

In the picture *The Embalmed Forest*, the bird-creature Loplop can be seen to have penetrated into the midst of the woods, the dotted lines of its body (an allusion to sewing patterns), indicating its ability to do so without being caught up in the trees. At the same time, the transparency of its body corresponds to the ease with which it can penetrate into this forest. In his usual poetical way, Max Ernst himself related the story of how this large painting was created, and Werner Spies has passed it on to us: in 1933, Max Ernst spent his holidays with some friends at the place of Vigoleno, where there was a large painting of St. George in the dining-room. Perhaps provoked by the mediocrity of the picture, Max Ernst went to Milan, bought a canvas of exactly the same size and painted the picture described above. When the staff, who had listened to Verdi's opera *Aida*, a few days previously with the house guests, saw the finished painting, they called out "La Foresta Imbalsamata" in reaction. Here they were referring to the duet in the second act, where Amonasro reminds his daughter of the "scented woods" of home.

Before 1934, Max Ernst often incorporated patterns such as pieces of wallpaper or ornamental elements into his work, making use of a Surrealist technique which enabled the beholder to see the object in question in a variety of different ways, beyond a mere identification of it. *Blind Swimmer (Effect of Touch)* (ill. p. 50) for example, gives rise to an impression of something caught up in a vertical, striped pattern which was probably made with a mechanical instrument, such as a wire comb, being pulled across the canvas to create an organic effect. At the same time, there is also an illusion of space, caused by the alternation of dark and light zones. Two light-coloured objects have penetrated into this sea of stripes, with a gamete developing out of a drop-shaped clot on the left, while the penetration in the middle of the picture is taking place in a more dramatic manner. With the title of *Blind*

Snow Flowers, 1929
Oil on canvas, 130 × 130 cm
(51¼ × 51¼ in.)
Basel, Fondation Beyeler

Swimmer in mind, the stripes take on the connotation of moving water. Seven pictures altogether were painted in this *Swimmer* series.

The very direct and obvious sexual meaning of these pictures has frequently been pointed out, and in this respect, *Effect of Touch* can be seen as an act of fertilization, with a sperm penetrating to an ovum. The inspiration for this picture was taken from an illustration of electro-magnetic currents in a science textbook, where the stripes were originally galvanic currents and the lancet-shaped "ovum" was an "Ampere's swimmer." Here Max Ernst was clearly harking back to the early days of his Dada period, when he made use of material that had nothing to do with art by incorporating textbook illustrations into his work. The large oil painting being discussed here is simpler and more monumental than the collages of the earlier days; the use of many illustrations of actual objects has been reduced to that of a few large ornamental components, which are now presented by the artist "Loplop." The simplified, ornamental pattern of this picture and the radical generosity of composition anticipated the heyday of pop art.

Loplop not only introduced himself and young girls, the grasshopper man and "woods filled with scent", he also presented whole landscapes. *Europe after the Rain I* (1933; ill. p. 54) appears to be a satellite image featuring an alienated old continent with new, changed contours. The ease with which the artist expresses substantial matters has turned the "deluge" – which brought death and destruction to the continent – into "after the rain." The overview shows what *The Horde* (ill. p. 44) has made of the "Rain Forests." Lakes and seas lie on

Europe after the Rain I, 1933
Oil on wood, 107 × 149 cm
(42¼ × 58¾ in.)
Staatliche Kunsthalle
Karlsruhe

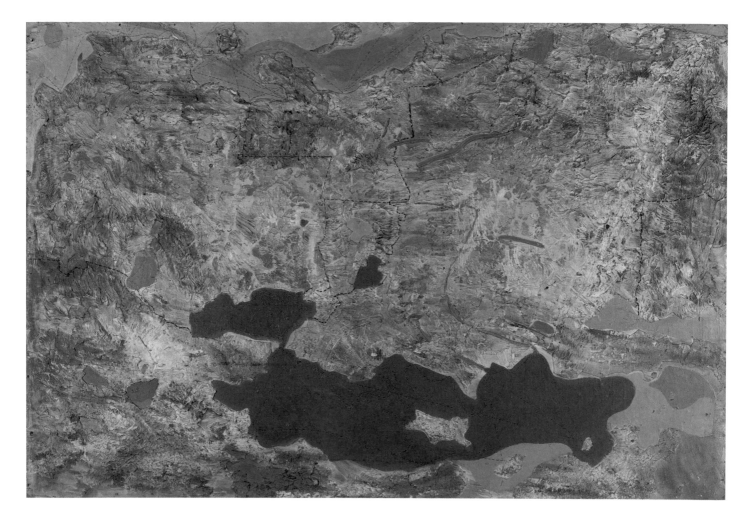

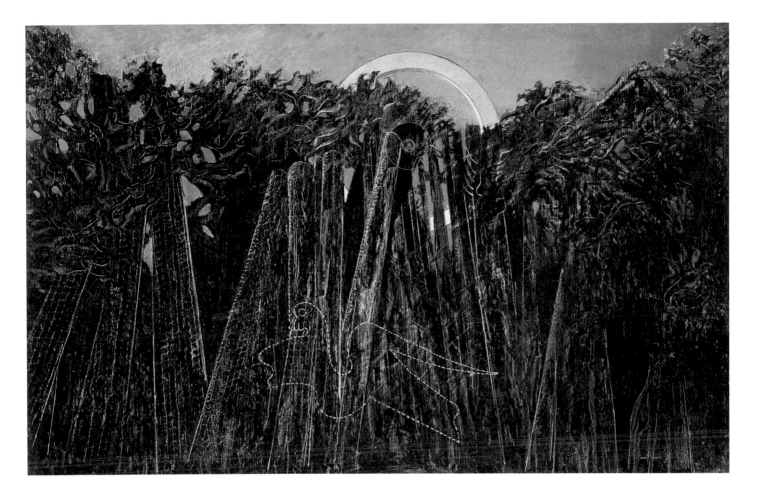

chapped areas of land streaked by rivers in different shades of blue. Shipping lanes are drawn in red. They seem to have been taken from sheets of sewing patterns. Dotted lines in black look like edges of sewing patterns and mark the new national borders. Loplop presents the new map· a "keywork of utmost importance to the emergence of post-war Informel and the textured paintings of Jean Dubuffet or Jean Fautrier" (Werner Spies). Thus, once again, this work expands the artist's "palette" in a decisive way. In its singular form as an extremely picturesque painting of a landscape, it simultaneously breaks the boundaries of the genre "Landscape painting." As an "earth life painting" (Gustav Carus) it clearly stands in the tradition of Romanticism. To this, Max Ernst added wit, serenity and irony to the beauty of the "soul landscape." The importance of this subject to him is clearly demonstrated by the second, entirely different version *Europe after the Rain II* (1940–42, ill. pp. 64/65), which is now in the Wadsworth Atheneum Museum of Art in Hartford, Connecticut.

The Entire City in Zurich for example (1935/36; ill. pp. 58/59), is an uncompromising view of a state of civilization that can only be described as desolate. Under a mercilessly large sun the ruinous remains of a once magnificent stronghold can be recognized, bringing the Acropolis to mind and hilltop citadels perched above cities. Here, the stone city, or its symbol, the city in the form of a stronghold, which seems to be held up by numerous layers of substructures, is positively glowing from the heat of the sun. Or is it cooling down in the aftermath of some other terrible heat? No signs of life are to be seen. Gigantic climbing plants and creepers are growing out of control, threatening to swallow up the works of man. The rampant vegetation in the foreground is advancing on the citadel without cease. One

The Embalmed Forest, 1933
Oil on canvas,
162.5 × 254 cm (64 × 100 in.)
Houston, The Menil Collection

feels that one day, only lumps of stone will remain to witness the passing of what were once proud and famous products of human culture. In this picture, the composition was carried out in the Romantic tradition.

At the same time the artist painted this picture, he produced a similar version (ill. p. 56) without a sun, referring back to the large cityscapes which had been the subject of a series of smaller pictures on mounted paper, in which the frottage technique played an important role. As in the "forest" pictures of the late twenties, he again used the grain of objects laid beneath the paper to form walls, stones and forbidding structures which nevertheless spur the imagination. However, these stone structure are more aloof in character than the earlier forest pictures.

After these cityscapes were produced, Max Ernst also made a series of pictures under the heading of "Aeroplane-Traps," in which architecture and vegetation were brought into a state of direct confrontation. The vegetation growing in *Landscape with Wheatgerm* (1936; ill. p. 60) is reminiscent of these plane-eating plants, and with both versions of *The Entire City* in mind, it seems that nature, in the form of the vegetation, has taken the castle, or human culture, into its grip and is about to swallow it up, obliterating it in a maelstrom of rampant natural forces.

It is quite clear that Max Ernst was quoting motifs from the collages of the early 1920's again, for the layers and strata are reminiscent of the illustrations in natural history textbooks he made use of as a means of overcoming prevalent theories of art. The close-up views in this picture, similar to the view through the microscope, reveal worlds which would

The Entire City, 1936
Oil on canvas, 97 × 146 cm
(38¼ × 57½ in.)
Private collection

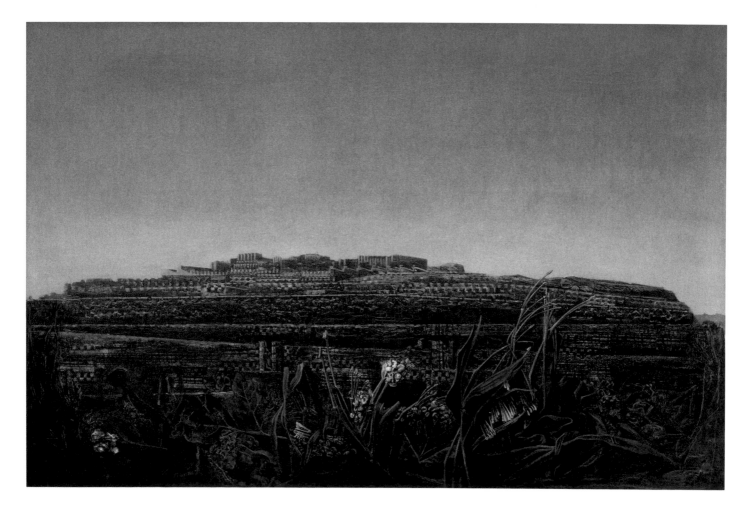

otherwise remain concealed beneath the blanket of a realistic means of perception. The alternation from close-up (in which the driving forces of the earth seem all the more powerful) to the long-distance view (of a mountain landscape evocative of Albrecht Altdorfer) is made all the more dramatic by the contrasting use of light and shade, forcing the beholder to constantly look at the picture in different ways. The cross-section of the earth, with its coiled intestines, reveals lemur-like creatures, half-plant and half-animal, eking out a dismal existence. A grasshopper with human hands is also visible, spread out diagonally across the middle of the picture. A green monstrosity, a cross between a double bass and a dinosaur, towers above the hill to the top left.

Vegetation and landscape are also the subject of *Joy of Life* (ill. p. 66). While in *Landscape with Wheatgerm* microscopically small forms take on monumental proportions, giving the picture a degree of almost classical clarity in spite of all the coils and convolutions, an impenetratable jungle obstructs the view in *Joy of Life*. On closer inspection people can be made out in the tangle of tropical plants. Eve, drowsy and naked, can be seen reaching behind her for a burst-open piece of fruit, her eyes closed as if in trance. Above her head the face of an old man with an imposing moustache can be recognized. At first both heads,

Day and Night, 1941/42
Oil on canvas, 112.4 × 146.1 cm
(44³/₈ × 57⁵/₈ in.)
Houston, The Menil Collection

The Entire City, 1935/36
Oil on canvas, 60 × 81 cm
(23⅝ × 32 in.)
Kunsthaus Zürich

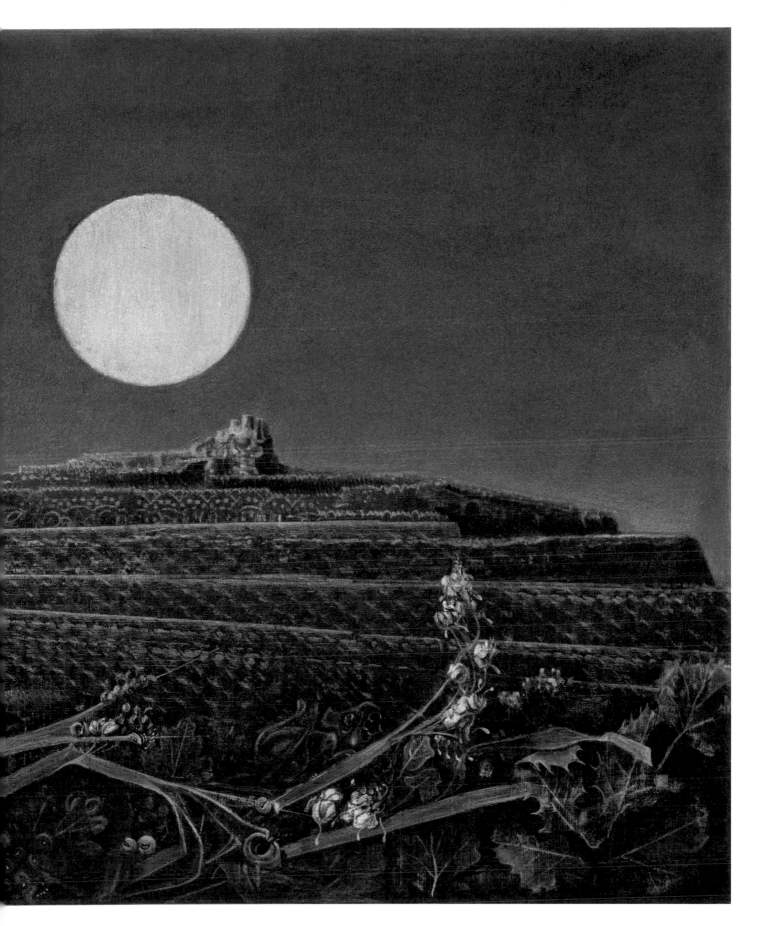

which are green as if in camouflage with their surroundings, seem to belong to the slender body of the woman. Plants are growing profusely, spreading over the impassable ground, looking like animals with their limbed-shaped fruit and stalks. The plants reaching up to the sky on the left-hand side of the picture are ostentatiously proffering blue and yellow fruit to the beholder. It only seems a small step from lust to greed in this picture, a greed that will devour everything in its path. An undertone of menace makes Eve's act of reaching for the fruit a gesture of despair. The jungle also obstructs our view of the landscape behind, with its distinct dark hills beneath a light-blue sky. There is no admittance to this paradise. Loplop presents the lust for life as a thoroughly deceptive desire, as a state where "eat or be eaten" would seem most applicable.

Despite individual differences, all the themes and subjects of Max Ernst's work had a political dimension. In order to demask bourgeois respectability he would criticize cultural values, while time-honoured Biblical and mythological subjects were used in profane and

Landscape with Wheatgerm,
1936
Oil on canvas,
130.5 × 162.5 cm (51½ × 64 in.)
Düsseldorf, Kunstsammlung
Nordrhein-Westfalen

banal connections in order to purify the Western tradition of art and make room for a new way of perceiving reality while making possible a change in consciousness. However, this educative aspect of his work was seldom related to political events as clearly as in *The Angel of Hearth and Home* (1937; ill. p. 61) series which consisted of three versions. One of these is illustrated above. Here one can see a gigantic bird or dragon-like creature launching into a terrible jump over a plain. At the left-hand side of the picture Loplop is trying to hold the monster back. Later, Max Ernst commented on the meaning of this picture by saying: "*The Angel of Hearth and Home* was painted after the defeat of the Republicans in Spain. The title ironically refers to a monstrous oaf, who destroys and annihilates everything that crosses his path. At the time, this was my impression of what would probably happen in the world. And I was right."

The picture was briefly given the title of *The Triumph of Surrealism* in 1938, supporting the view that the figure on the left is that of Loplop, the representative of Surrealism, helplessly trying to hinder the much larger angel of destruction in its doings. With the Spanish Civil War in mind, the landscape can be interpreted as representing the elevated plains of Spain with a chain of mountains slightly dusted with snow in the background. The despair and sense of helplessness concealed by this picture can only be appreciated when one considers that Max Ernst had originally wanted to join one of the "international brigades" in order to fight on the

The Angel of Hearth and Home, 1937
Oil on canvas, 54 × 74 cm
(21³⁄8 × 29¹⁄4 in.)
Munich, Pinakothek der Moderne

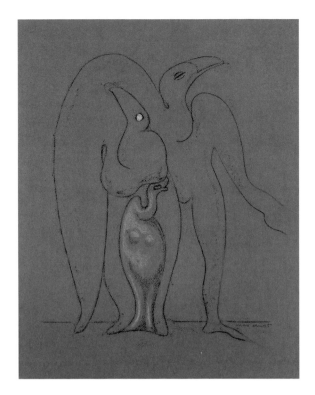

side of the Republic; he was prevented from doing so by André Malraux, who was in charge of recruitment and who flatly refused to let him join up, despite the fact that he had already gathered military experience as an artillery officer.

Max Ernst's existence and thus his chances of work were increasingly affected by the outbreak of World War Two and the occupation of France by German troops. Shortly beforehand, he had found a place to live and work at Saint-Martin d'Ardèche, north of Avignon, where, with the help of Leonora Carrington, he turned a tumbledown house into a kind of bestiary, furnishing the outer walls with cement bas-reliefs of legendary medieval creatures. *The Robing of the Bride* (ill. p. 69), a famous picture which harks back to the collage-novel *Une Semaine de bonté*, was probably painted here. In a room, which is more reminiscent of a stage setting from the period of Mannerism than of the Renaissance, the old ritual of preparing the bride for the wedding is taking place, a ritual which stirs the imagination of the wedding guests each time it takes place. The symbolism involved is obvious, especially in view of the attributes of the birdman attendant. The central motif is reflected in a mirror on the wall, emphasizing the theme of the picture. In view of the political consciousness of the artist, the picture can also be seen as a hidden reference to the dangers involved in a marriage of the French bride to the German barbarian.

In 1939, Max Ernst was sent to an internment camp near Aix-en-Provence, but Éluard interceded on his behalf and he was discharged a few weeks later. After the German advance, he was arrested again in the winter of 1939/40 and a restless time began, for he escaped and was arrested again several times before he finally managed to flee to America with the help of Peggy Guggenheim, an influential sponsor of the arts and a close friend. *Marlene* (ill. p. 63) and *Europe after the Rain II* were among the last pictures the artist produced before his departure from Europe. Marlene was carried out in the decalcomania technique which had been used for the first time only shortly beforehand. The special thing about this technique is that the paint is not applied to the canvas with a brush, but is pressed against it with a flat surface (usually a piece of glass, as in the monotype process). Once the paint has dried, it takes on a mossy, furry or marshy appearance.In this picture, which is about emigration, *Marlene* has taken to the road with her children. She is leaving Mediterranean civilization, which is indicated by the pillar and the cypress tree growing to the far right, and setting off for distant shores with her children, birds of every variety. This picture gives rise to so many associations that it is advisable to be very cautious in order to avoid falling into any traps the artist might have laid. However, it does seem probable that Max Ernst was probably thinking of his own escape, which was organized by Peggy Guggenheim, in view of this exodus to the New World at the side of a half-naked woman with a face very similar to Marlene Dietrich's, who emigrated to America herself in 1937. Assuming this interpretation to be valid, the bird-like creatures can be seen as embodiments of the artist himself.

Before he emigrated to America, Max Ernst also painted an apocalyptical landscape showing Europe after the rain, or in other words, after the war, with what was truly prophetic foresight. In a leafless, petrified swamp, living beings that have been swept into this whirlpool of dissolution can be made out on closer inspection. Some are the torsos of women, embedded in the swamp or turned into pillars of salt like Lot's wife in the Old Testament,

Untitled (The Bird People),
1942
Colored crayons on orange wove paper, 45.5 × 35.5 cm
(17¹⁵/₁₆ × 14 in.)
The Art Institute of Chicago

Marlene, 1940/41
Oil on canvas, 23.8 × 19.7 cm
(9³/₈ × 7⁷/₈ in.)
Houston, The Menil Collection

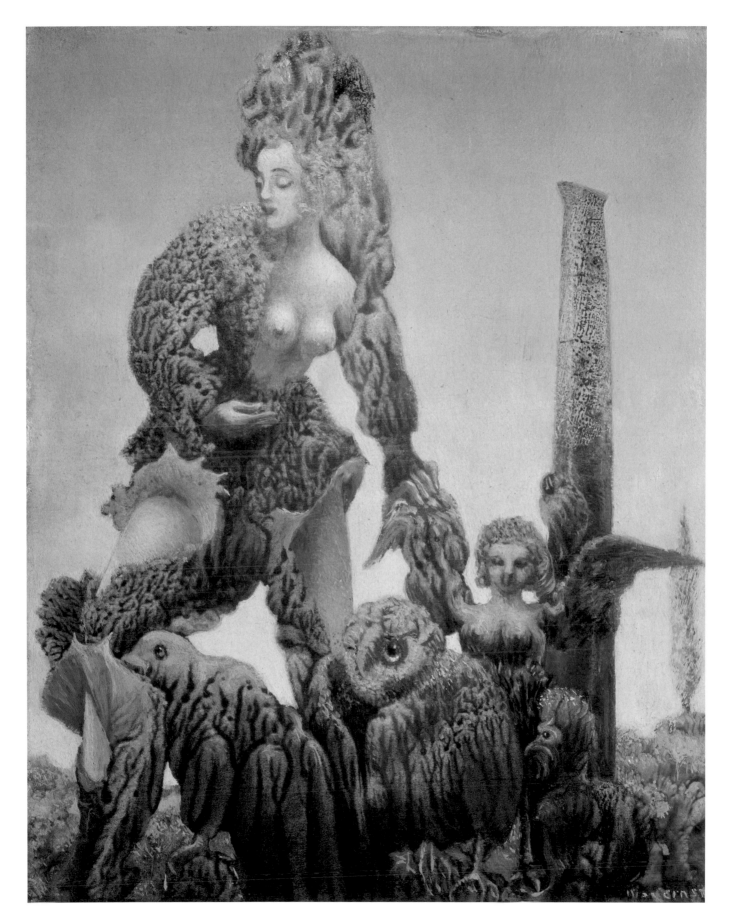

while others are bird-like creatures or guards. There is also an ox with a skull-like head, armed with steel cuffs. It is perhaps interesting to mention that when the artist realized he could no longer take this painting along with him on his difficult journey to America, with its many interruptions, he simply addressed it to Max Ernst, c/o Museum of Modern Art, New York and sent it off. Painter and painting arrived in America almost at the same time. Two years later, once he had gained a foothold in the New World, he worked on the picture again, hence the title *Europe After the Rain II*. The theme of a strange, swamp-like and petrified world was taken up again in *The Eye of Silence* (ill. p. 67), which was painted between 1943 and 1944.

Day and Night (ill. p. 57), painted soon after his arrival in America and now part of the famous Max Ernst Collection of the De Menil family in Houston, took up this type of landscape again (which was developed out of the decalcomania technique), albeit in slightly altered form. Here the unity of the landscape was broken up into individual segments in accordance with the principle of the collage. The simultaneousness of different levels of sense experience is vividly expressed by the co-occurrence of day and night, a cosmological

impossibility. It is probable that the artist had been influenced by old works of art, stored away in museum vaults, for the lighter areas in this painting look like the patches which result when restorers test small areas of a darkened old picture for its reaction to cleansing. The title, which is based on the song "Night and Day," composed by Cole Porter, the American jazz musician, amounts to a homage to the New World. In 1944, Max Ernst commented on this painting himself, saying: "Night and Day, or The Pleasures of Painting: to listen to the heartbeats of the earth. To yield to that fear which comets and the unknown inspire in men. To put out the sun at will. To light the searchlights of night's brain. To enjoy the cruelty of one's eyes. To see by the soft gleam of the lightning. The majesty of trees. To invoke the fireflies."

The effect that the work of Max Ernst and other emigrant artists had on the American art scene in general and the New York one in particular has been more concealed than revealed by American art historians. Today, individual biographies and studies of the origins of American schools of painting make it clear that in addition to the Bauhaus emigrants, including above all Josef Albers with the work he did at Black Mountain College, artists such as Piet

Europe after the Rain II,
1940–42
Oil on canvas, 54.8 × 147.8 cm
(21⅝ × 58¼ in.)
Hartford, Connecticut,
Wadsworth Atheneum
Museum of Art, The Ella
Gallup Sumner and Mary
Catlin Sumner Collection
Fund, 1942.281

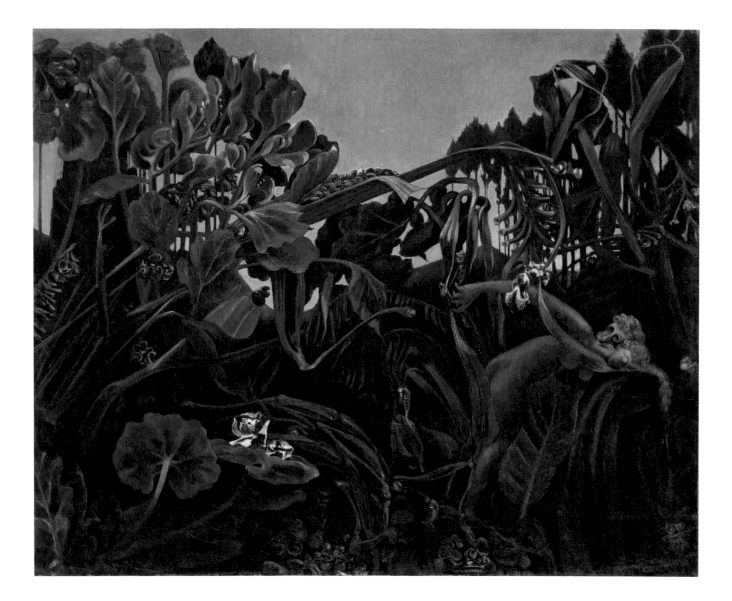

Mondrian, Max Beckmann, Salvador Dalí and Max Ernst also had a very strong influence, both direct and indirect, on the development of the different schools of American art. Abstract expressionism and action painting would be inconceivable without Max Ernst, as would Colorfield Painting with its "all-over structure," a form of painting where, instead of using traditonal means of composition, the whole canvas is covered with a structure which makes it impossible to determine right and left, above and below. This European influence, which had begun in the twenties and thirties thanks to the efforts of the alert and internationally well-informed art magazines of the time, now took on the form of personal acquaintance between the emigrant artists and their American colleagues, who were up to a generation younger, and had a stabilizing and strengthening effect on new movements in American art.

New Yorkers, and above all, interested young artists, first came into contact with a large number of Max Ernst's works in 1932, when the Levy Gallery presented his first solo exhibition in the USA. The exhibition "Fantastic Art, Dada, Surrealism," which was held by The Museum of Modern Art in 1936, was able to reach a far wider section of the public, however. There he was represented with 48 paintings, by far the largest number of pictures by an individual artist to be displayed at this exhibition, where Salvador Dalí, René Magritte, André

Joy of Life, 1936/37
Oil on canvas, 60 × 73 cm
(23⅝ × 28¾ in.)
Munich, Pinakothek der
Moderne

Masson and Joan Miró also exhibited. Salvador Dalí, who knew how to present himself in society to greater effect, became the leading exponent of Surrealist art in the forties and fifties, a position he has held until the present day but which has always been Max Ernst's by right. Indeed, the methods Max Ernst developed to stay "beyond" the classical way of painting taught at art schools have had an enormous influence on international art, as any encyclopaedia of art will confirm: collage, assemblage, montage, grattage and decalcomania are techniques which he either developed himself or made use of in such a way that they soon became acceptable to both art schools and society alike. Just as the Bauhaus, especially in its preliminary courses, used analysis of materials in a way which has influenced artistic work methods up to the present day, so too, by way of compensation and balance, Max Ernst introduced his method of Surrealism (which involved a certain mechanical component in reaction to these rational "investigations"), which has encouraged artists all over the world to discover new methods for themselves.

In one of his major works, *Surrealism and Painting* (ill. p. 77), the figure of Loplop can be seen again, presenting a newly discovered way of painting, albeit somewhat indirectly. Here we see an "organic monster – a mixture of the elephant of the Celebes and the archaeopteryx,

The Eye of Silence, 1943/44
Oil on canvas,
109.8 × 142.8 cm
(43¼ × 56¼ in.)
St. Louis, Mildred Lane
Kemper Art Museum,
Washington University,
University purchase,
Kende Sale Fund, 1946

which was incapable of flight" (Werner Spies) – occupied with two things at once. On the one hand it is devoting its attention to itself and its offspring, a brood of children, (awakening memories of the Christian symbol of the pelican, which nourishes its young with its blood) while on the other it is using one of its tentacle-like wings to paint lines reminiscent of mathematical curves and the flight paths of stars onto a canvas propped up on an easel in the right-hand corner of the picture, holding what appears to be a long and thin slate pencil or paintbrush somewhat affectedly in its hand. It does this without looking at what it is doing, for its red and yellow head is turned to its children. The central group can be seen as a family scene, with Loplop paying the greatest attention to the bird-like figure on the left, which can be recognized as a female with its soft and swelling contours. Loplop himself is seated on a crate, open to the front and containing tools which can be regarded as symbolizing new kinds of painting utensils.

Before interpreting this picture any further, which should not be too difficult in view of the programmatic title, the discovery of the new technique referred to above should be briefly described. The painting propped up on the easel is the result of a technique discovered by Max Ernst in New York. As he explained at the time: "Tie an empty can to a piece of string one or two yards long and drill a small hole in its bottom. Now fill the can with paint and allow it to swing backwards and forwards above a flat canvas. Guide the can by movements of the hands, the arms, the shoulders and the whole body. In this way amazing lines will trickle onto the canvas. The game of free association can begin." What Max Ernst has described here would one day be christened "dripping" by Jackson Pollock, the major artist of action painting.

In his book, also named *Surrealism and Painting* which was published in 1928, André Breton stipulated in a quasi-scientific manner the methods that were to be used in a Surrealist piece of work. One of these methods was the so-called "écriture automatique" ("automatic writing") in which thoughts produced by the unconscious were written down without the censorship of rational thought. This somewhat rigid and dogmatic approach to Surrealism, which led in the long run to the division of the movement into two groups, with André Breton and Communist artists on one side and Max Ernst and Paul Éluard on the other, is referred to in the *Surrealism and Painting* picture with light-hearted naivety. While preoccupied with wife, family and himself, the artist paints a clear and serene-looking sky without even looking at what he is doing. He is not in his studio, in that artist's cell where energy is frequently wasted in a fruitless and introspective attempt to overcome lack of drive; he is working under a friendly and open sky. If this line of thought is followed any further, it will become apparent that the picture contains a hint of how to escape from the blind alley that dogmatic Surrealism had got stuck in. Many American artists took the hint and abandoned old and unfruitful standpoints and the Surrealist idiom, creating in the process the basis for the immense impetus that then took place in American painting, freeing it from the dominance of European art and bringing it into a leading position itself.

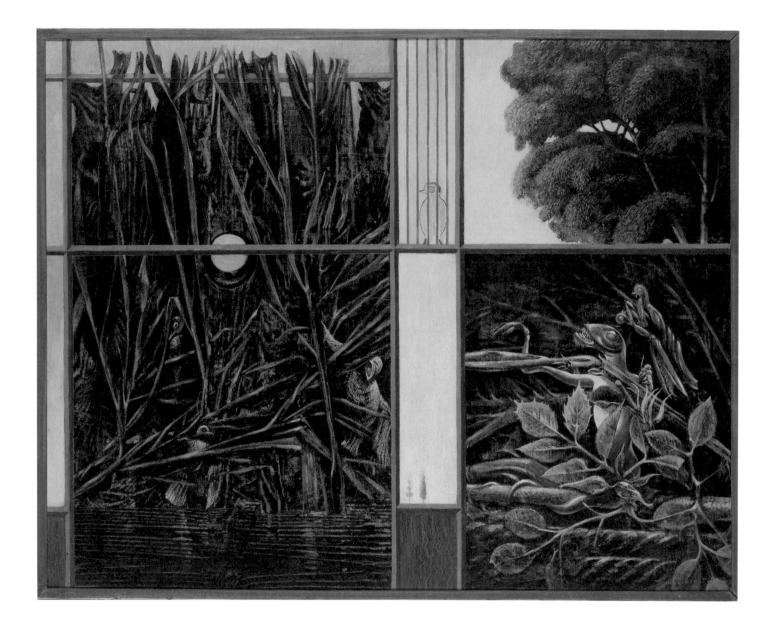

Painting for Young People, 1943
Oil on canvas, 61.4 × 76.6 cm
(24¼ × 30¼ in.)
Houston, The Menil Collection

Vox Angelica, 1943
Oil on canvas, 152.4 × 203 cm
(60 × 80 in.)
Private collection

The second innovation that Max Ernst brought about, that of an encyclopaedic way of painting in which Loplop gave artists the freedom to dip into the treasure-chest of subject-matter and take out whatever they felt like playing with, was more limited, as in the case of *Surrealism and Painting, Vox Angelica* (ill. p. 71) and *Painting for Young People* (ill. p. 70), which were both produced in 1943, were resumés of his past methods of work. The story of how *Vox Angelica* came into being has been passed on to us. At the time the painting was produced, Max Ernst was staying at the She-Kay-Ah Ranch (near Sedona, Arizona, where he was later to live), living in a small cabin placed at his disposal by the owner of the ranch, who was apparently a descendant of Gottfried Wilhelm Leibniz. Here the artist spent the summer of 1943 with the painter Dorothea Tanning. The painting, which not only in its title is reminiscent of a medieval altarpiece, measures 152 × 203 cm and is divided up into 52 segments. (Max Ernst was also 52 years old at the time). The painting not only includes the techniques of frottage, grattage and decalcomania, it also displays a whole arsenal of simple tools, including a ruler, a pair of dividers, a drill and a pair of callipers used in sculpture for copying and transferring dimensions. The picture is divided up into segments by narrow little bars reminiscent of monads (to use the Leibnizian term). Generally speaking, the large segments can be classified into two different types, consisting of open views and others which are caged in. The landscape segments, which were carried out in the decalcomania and grattage techniques, are like the apocalyptic world visions of the late Gothic period, reminding Werner Spies of Matthias Grünewald's *Isenheim Altarpiece* and especially its angels' concert ("Vox Angelica"). In contrast to these landscapes, the picture also contains segments showing clear blue skies and fields of green and other colours, with colourful rays unfolding to show a world of freedom, in which the little bird in the right-hand bottom corner can feel at home in its peaceful surroundings.

In this picture, Loplop is taking stock of a world that has survived the catastrophe, a world where much has been destroyed but where there are still open horizons. For the emigré Max Ernst, the stay in Sedona was a short sojourn in Paradise and it was here that he came into contact with the culture of the Hopi Indians, which led to the development of a new stylistic language. The bird is still held captive with Eve and the snake, but the dividers, the rulers and other drawing instruments, and most especially the technique of "dripping," point the way to freedom. *Design in Nature* (ill. p. 76), which was painted in 1947 and *Feast of the Gods* (Vienna, mumok – Museum moderner Kunst Stiftung Ludwig Wien), which was produced a year later, were both carried out in the new geometrical technique. Here a world constructed with dividers and a ruler proved to be the means of escape, a world which, in the case of the "Feast," can be seen to glow with a joyful sense of colour. Here a natural atmosphere, soaked in light and sunshine, takes the place of the bitterness felt in *The Cocktail Drinker* (ill. p. 75), an ironical analysis of the world of New York parties. It was only a small step from *The Feast of the Gods* to the development of the new sculptures in Sedona.

We have already commented on Max Ernst's earliest sculptures, assemblages of hat forms, plaster elements, wire and pieces of wood, which have for the most part since been destroyed, in the the first chapter of this book. Even in those days his pieces displayed a characteristic which was to remain until the very end: the lack of any further modelling or moulding once they had been put together. Along with

Correspondances dangereuses, 1947
Dry-point engraving,
30 × 22.5 cm (11⅞ × 8⅞ in.)
Hanover, Sprengel Museum

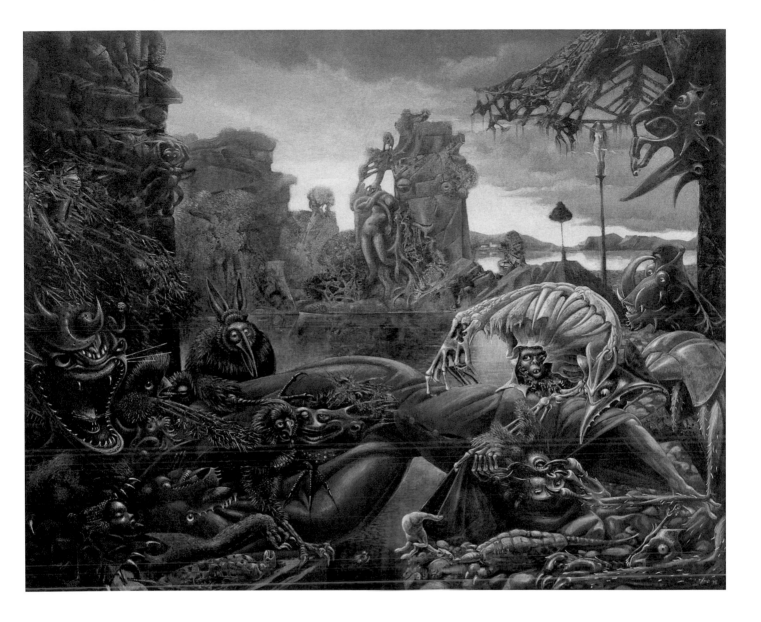

The Temptation of
St. Anthony, 1945
Oil on canvas, 108 × 128 cm
(42⅝ × 50½ in.)
Duisburg,
Lehmbruck Museum

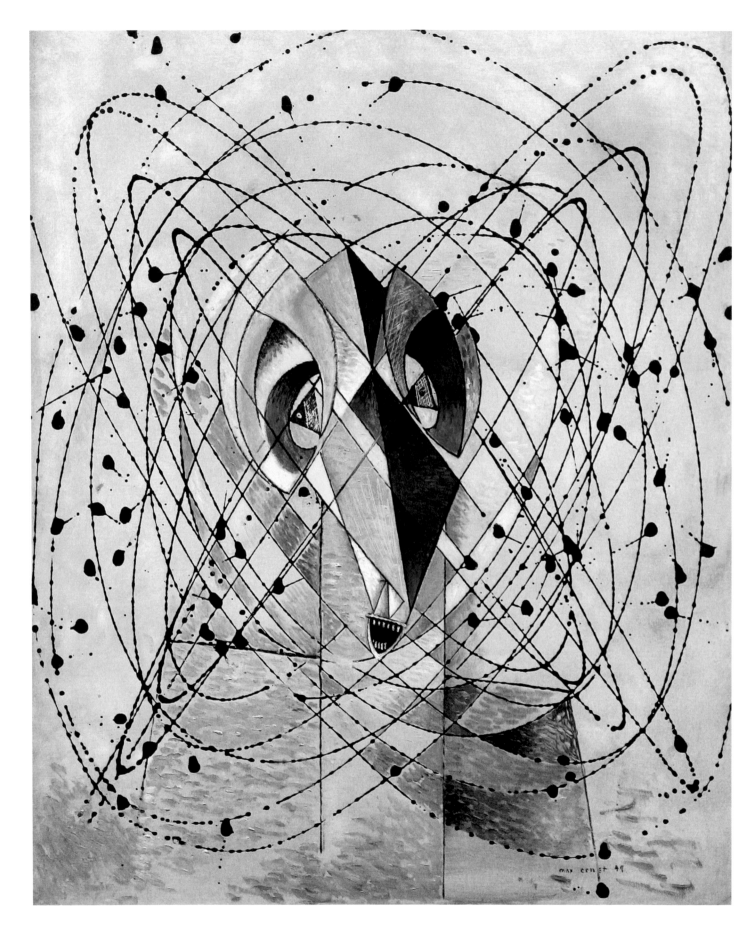

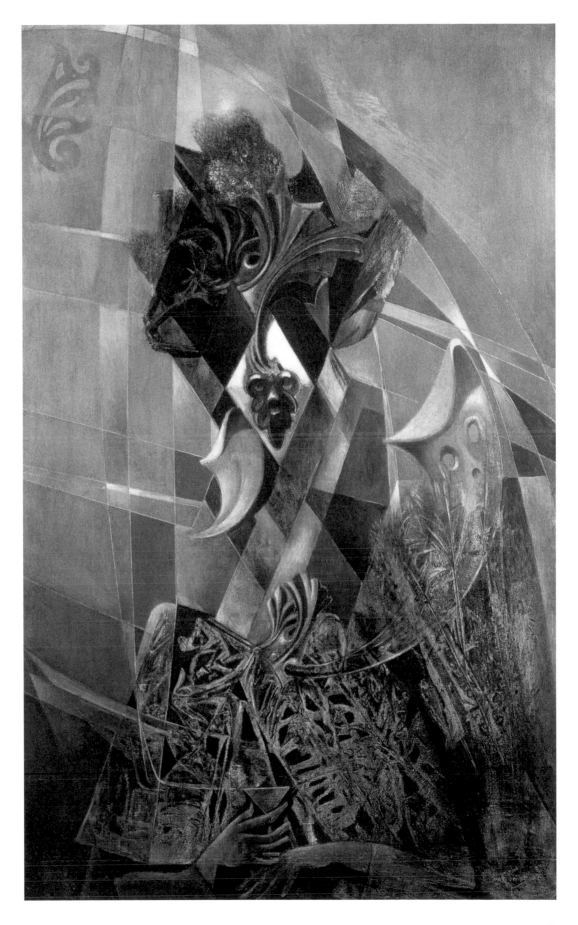

*Young Man Disconcerted
by the Flight of a Non-
Euclidean Fly,* 1942/47
Oil on canvas, 82 × 66 cm
(32³/₈ × 26 in.)
Staatliche Museen zu Berlin,
Nationalgalerie

The Cocktail Drinker, 1945
Oil on canvas, 116 × 72.5 cm
(45³/₄ × 28⁵/₈ in.)
Düsseldorf, Kunstsammlung
Nordrhein-Westfalen

the collage, the assemblage of objects having nothing to do with each other became a permanent design principle. It was first in 1934, after he and Hans Arp had spent some time among the glacial mountains of Maloja in Switzerland (where he began to incorporate stones that had been ground to a round shape by the Forno glaciers), that the forms came into being which were to determine the sculptural work of the forties. His preference for these smooth round shapes harked back in style to the hat forms of the early Twenties. All the sculptures made during this time look like sculpted, modelled objects but in reality they were cast out of individual parts which were then mounted together with concealed seams. The rough cement bas-reliefs of medieval legendary creatures on the house in Saint-Martin d'Ardèche were an exception to this, due to the fact that they were directly modelled onto the walls.

By 1944, Max Ernst had established himself in the USA fairly well and was able to set up a studio for plaster-work near Great River on Long Island. The two-sided sculpture *A Solicitous Friend* (1944) (ill. p. 78 bottom) was made here, along with a number of other pieces which mainly consisted of found objects assembled in ever-new combinations. These sculptures

Design in Nature, 1947
Oil on canvas, 50.8 × 66.7 cm
(20 × 26⅜ in.)
Houston, The Menil Collection

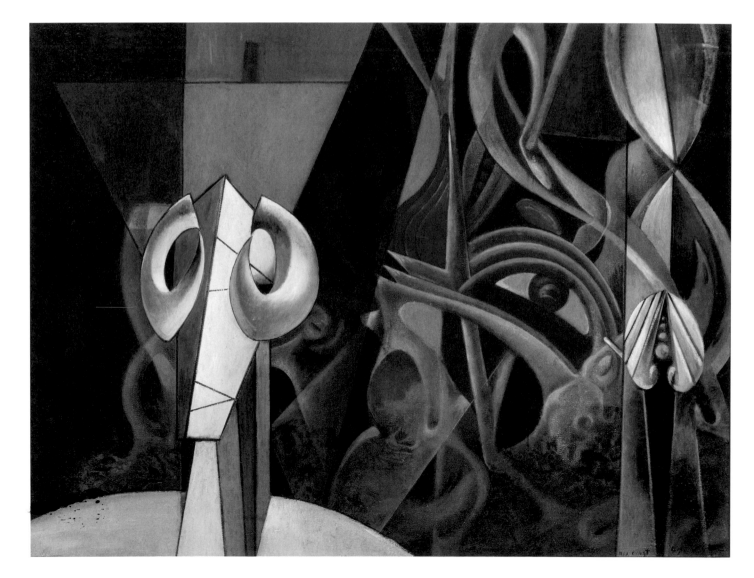

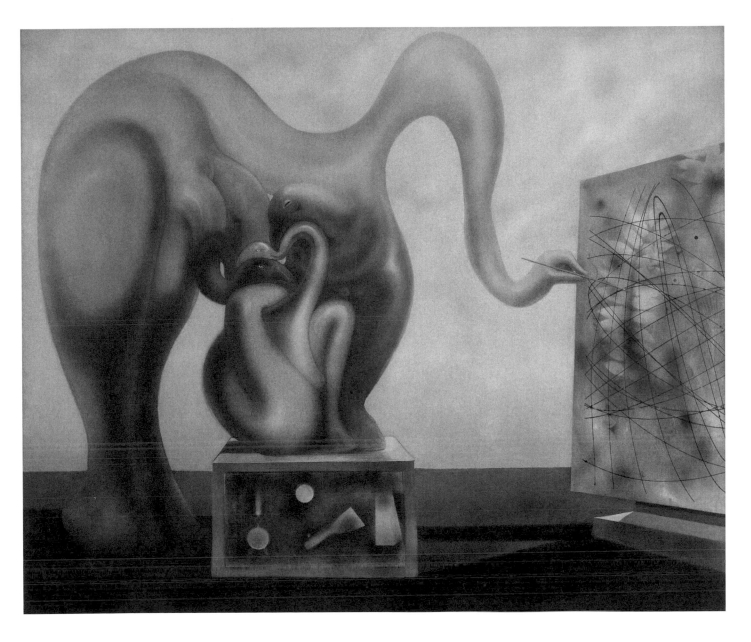

Surrealism and Painting, 1942
Oil on canvas,
195.6 × 233.7 cm (77 × 92 in.)
Houston, The Menil Collection

were first to be cast in bronze and made accessible to a wider public on a broader base at a later date. The "Solicitous Friend" unfolds its complicated and two-sided personality in the confusing interplay of front and back. Moreover, as a "solicitous friend," it not only has two sides, it also has two sexes, and once again, it combines animal and human characteristics to form one of those mixed creatures that frequently occur in the artist's work.

The *Capricorn* group (ill. p. 79) is Max Ernst's major sculptural piece of work. It was produced in 1948 for his house in Sedona, where he had been living with his fourth wife, Dorothea Tanning, since 1946. The free-standing object, larger-than-life, was originally made of cement as a kind of seat. Like *Vox Angelica*, it can also be seen as an encyclopaedic piece of work, combining elements from many different phases to form a new whole. In the form of Loplop, Max Ernst presents us with a caustic but happy picture of a family idyll, a theme to be met with again and again throughout the whole period of his work. The mighty seated figure, himself inviting us to sit down on him, is holding a monumental sceptre in his right hand. His bull-like skull is crowned with horns reaching to the sides and in his left hand he holds a small creature, which clearly derives from the moon-faced woman seated at the right. The lower part of the woman's body is made of a fish, showing her to be a mermaid. An oval-faced dog is sitting under the left arm of his master, on his lap, so to speak.

Not all the details were freely moulded but were formed out of cement casts of objects of different origin. For example, the sceptre is made of four milk

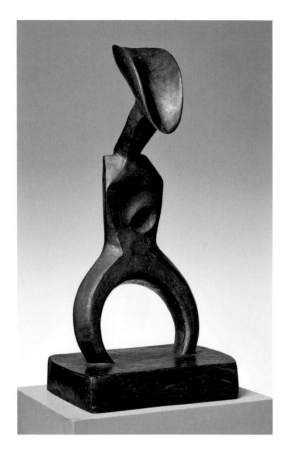

bottles placed on top of each other and crowned with the cast of a Hopi mask (which has the magic ability to ward off evil) as the symbol of this bull-headed patriarch. The characteristic features of this autocratic figure are the feet, the penis and the trunk-like snout. The female figure is somewhat goat-like. Her long bent neck and the lower part of her body, which is shaped like a fish, are made of automobile suspension springs covered in cement. The upper part of her body consists of a large kind of stringed instrument, perhaps in homage to Magritte. The feather in her hat, which looks like a fish, is also made of a suspension spring. The ibex ("Capricorn") may be holding audience with his family, but it also stood guard over the home of the newly-wedded pair, an inviting but protective figure.

When Max Ernst had to give up his house in Arizona in 1953, moving back to France in accordance with his European roots, he took the immovable sculpture along with him in

Young Man with a Fluttering Heart, 1944
Bronze, ca. 65 × 34 × 22 cm
(25⅝ × 13½ × 8¾ in.)
Staatliche Museen zu Berlin,
Nationalgalerie

A Solicitous Friend, 1944
Bronze, 66.8 × 34.8 × 40 cm
(26⅜ × 13¾ × 15¾ in.)
Duisburg,
Lehmbruck Museum

the form of a plaster model. Once in France, he had a series of bronze casts made at the famous Suisse Foundry at Arceuil near Paris. The version illustrated here, which is to be found in the National Gallery in Berlin, is the plaster model which was used to form the other casts. Today one of these bronzes has taken up its place in Seillans, enthroned in the open setting of a Mediterranean landscape. This monumental group of figures is truly encyclopaedic, for it incorporates all the elements Max Ernst had previously used in his work. At the same time, the lighthearted yet sharply ironical tone points to the late period of his work, which was begun in the sundrenched landscape of Arizona and which was to end in the South of France.

Capricorn, 1948
Coloured plaster,
247 × 210 × 155 cm
(97¼ × 82¾ × 61 in.)
Staatliche Museen zu Berlin,
Nationalgalerie

The Return of the Fair Gardener
1950–1976

The title of this chapter is not only a reference to the picture of the same name, which was painted in 1967, it also stands for the return of the artist from his enforced emigration to America to the old world of Europe and the country of his choice. This journey "home," which took several months, began in New Orleans. In his autobiography Max Ernst wrote: "Returning to Europe by ship from New Orleans. Paris revisited. Mixed feelings..." In 1951, the artist's first solo exhibition to be held in Germany took place in his home town of Brühl. The excellent exhibition, which proved to be a special event for all fans of modern art, ended in a financial fiasco for the organizers. In a hopeless attempt to raise funds, they sold a picture that the artist had donated to city at cut-price, and dismissed their arts officer, all to no avail. Their scandalous behaviour was to overshadow the intellectual atmosphere of Brühl until at least 1966. The result of all this discord was the refusal of the artist to accept the Honorary Citizenship offered to him by the town.

In 1954, a year after his final return to France, Max Ernst was awarded the top prize for painting at the Venice Biennial, receiving the recognition that had generally been denied him in the land of his birth, in his chosen home of France and in America. For an artist whose aim in life was to work "beyond painting," as we have suggested in the subtitle of this book, winning the prize for painting must have seemed very ironical indeed. However, it also made it possible for him to work without pressing financial difficulties for the first time in his life.

One of the first pictures to be painted after his return to Paris was *Colorado of Medusa, (Color-Raft of Medusa)* (ill. p. 85). The title, which is a combination of Colorado and the French word "radeau," which means "raft," is reminiscent of the early Dada period, when the artist often used to coin words in this way. This was also the time when *The Fair Gardener* was painted, which would seem to imply that this late piece of work was a conscious "return" to the association of unconscious ideas, an important method which was discovered in the twenties and refined still further over the years. The title, and most likely the picture, is based on an 11-day trip Max Ernst, Dorothea Tanning and five other passengers made down the Colorado River in 1948, during the course of which they were reported missing by the press. The name of the title is also reminiscent of a masterpiece by Théodore Géricault called *The Raft of Medusa* (1817–1819), which is in the Louvre.

In this picture, the yellow eye of a pale sun hangs above the crests of huge, luminous waves. In the surge of water at the bottom of the sea, or on the raft itself, two beings meet: a yellow fish and a mermaid with the head and shoulders of a sphinx. The sea and the sky are not clearly differentiated from each other. The individual zones and fields of colour can be interpreted as standing for the bands of coloured rock that line the walls of the famous Grand Canyon, the bed of the Colorado River. Everything has a velvety touch, which the artist achieved

Return of the Fair Gardener, 1967
Oil on canvas,
161.9 × 129.5 cm (63¾ × 51 in.)
Houston, The Menil Collection

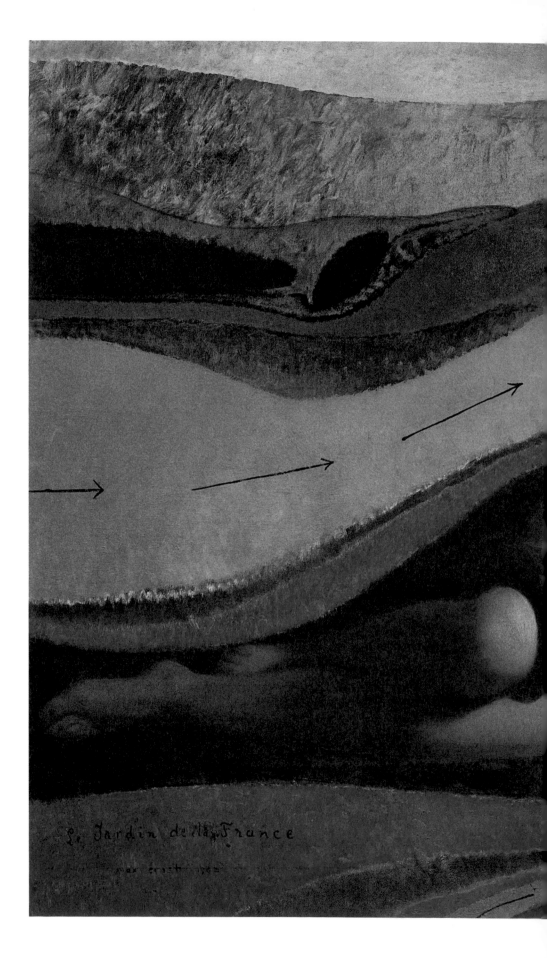

The Garden of France, 1962
Oil on canvas, 114 × 168 cm
(45 × 66¼ in.)
Paris, Centre national d'art et
de culture Georges-Pompidou

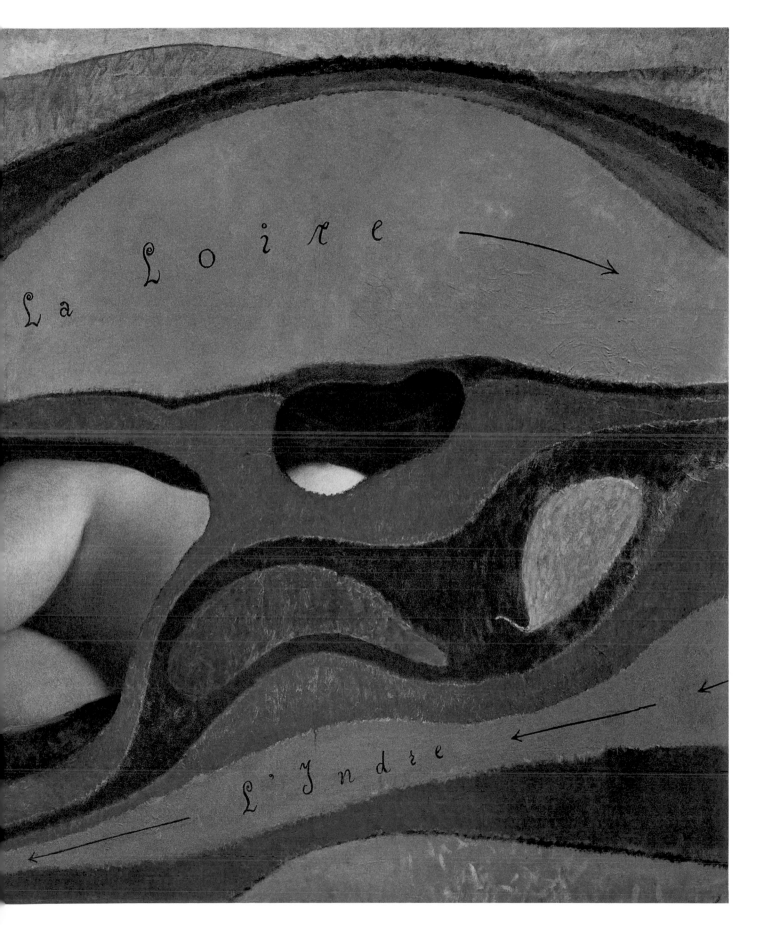

Figure, 1950
Etching and aquatint,
23.6 × 17.8 cm
(9⁵/16 × 7¹/16 in.)
The Art Institute of Chicago

*Colorado of Medusa
(Color-Raft of Medusa),* 1955
Oil on canvas, 73 × 92 cm
(28¾ × 36¼ in.)
Private collection

by rubbing away the surface of the paint, an effect which unites the various fields and areas of the picture into a single whole. As in the days of his early work, the painting gives rise to contradictory associations – the waves could be hills and the bottom of the sea could be a valley, the fish seem to be stars and the human beings have taken on the form of legendary creatures.

After having spent a relatively short length of time in Paris, Max Ernst and his wife settled down in Huismes in 1955, near Chinon in the Touraine area. It had almost become a tradition for him to turn his back on city life, the centre of artistic activity. In the twenties, for example, he frequently left Paris for the Alps or the Far East and he then moved to the South of France in 1938. His stay in New York was not a long one either.

A new series of paintings, completed between 1956 and 1973, such as *The Birth of a Galaxy* (ill. p. 90) and *Rien ne va plus* (ill. p. 91), took up the theme of the "layered" landscapes of the twenties again in a new, simplified and more radical form, as in the case of *The Colorado of Medusa*. The special attraction of these pictures is easier to explain if the means of production are taken into consideration, as is so often necessary in the case of Max Ernst's work. These pictures were not painted standing upright on an easel, but were laid out flat over carefully prepared objects and materials. The grain of these materials was then transferred to the canvas by means of the frottage technique. This process, which is often hidden under subsequent layers of paint, led to a change in the objects used, freeing them of their innate meaning. A similar change in meaning took place again when the canvas was picked up from its horizontal position and hung on the wall in an upright one. The change thus brought about by the pictures being seen first from above and then from the front is responsible for the feeling of alertness and tension present in all of the paintings described here.

This open form of composition – which gives the beholder the freedom to decide for himself what is above and what is below, or at least to let his imagination determine the field of action in which the inexpressible is taking place – is to be found in all the pictures of the late period to a greater and lesser degree. In the 1956 picture, *A Virgin, a Widow and a Wife* (ill. p. 86), three microbe-like beings, which the artist had already developed as a series in 1953, can be seen leading a strange existence (as the title suggests) in a space divided into two by a red zone. The title seems to allude to phases of development, comparing stages in human life to biological processes, thus reducing the cycle of human existence to the fairy dance of a handful of microbes and robbing it of all pathos in the process. In this way, the artist was expressing his contempt for rituals of society and rules that had been passed on throughout the course of history. Here a poetic kind of anarchy becomes evident, an anarchy which was to become the dominant characteristic of his late work. In the picture *Sign for a School of Monsters* (ill. p. 87), the microbes have become friendly monsters who have made themselves at home on the borderline between the strong contrasts of a black sky and a red earth. The "sign" referred to seems to be proclaiming that "this is a nice place to live."

In *The Garden of France*, painted in 1962 (ill. pp. 82/83) and *Ubu, Father and Son*, 1966, (ill. p. 89), the artist drew on the idioms of the twenties once again. Here a nude female is to be seen embedded in a river landscape built up in the manner of the earlier "layered" pictures. This figure is the naked personification of France, emerging from the earth with all her charm and appeal. Unlike the naked figure in the 1921 collage *Approaching Puberty* (ill. p. 21), whose origin remained unknown, the nude in this picture was taken from a copy of *The Birth of Venus,*

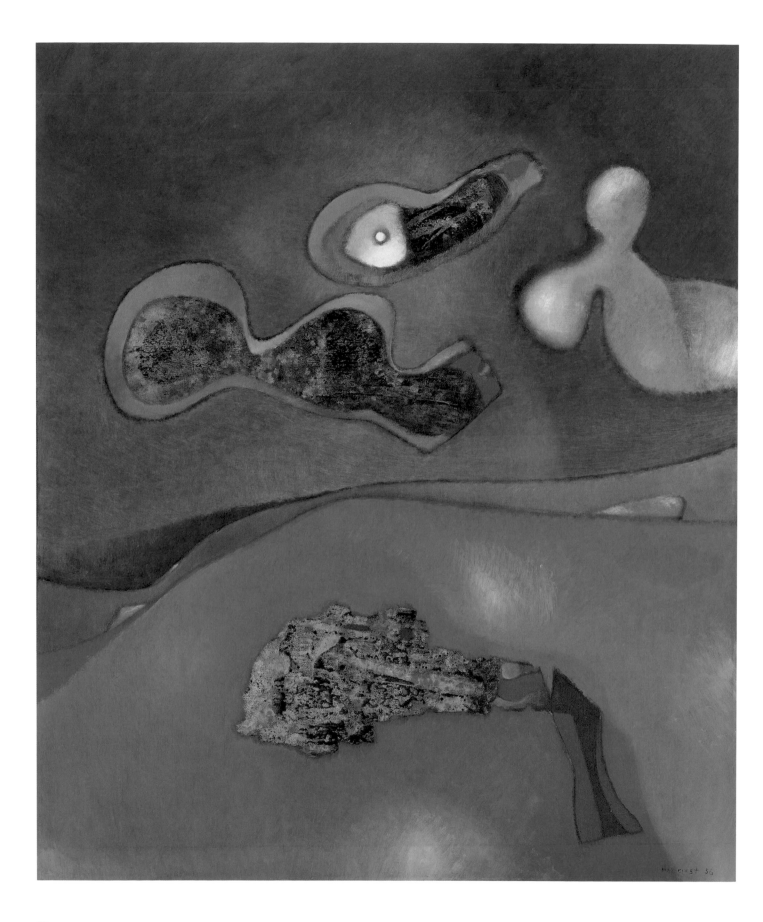

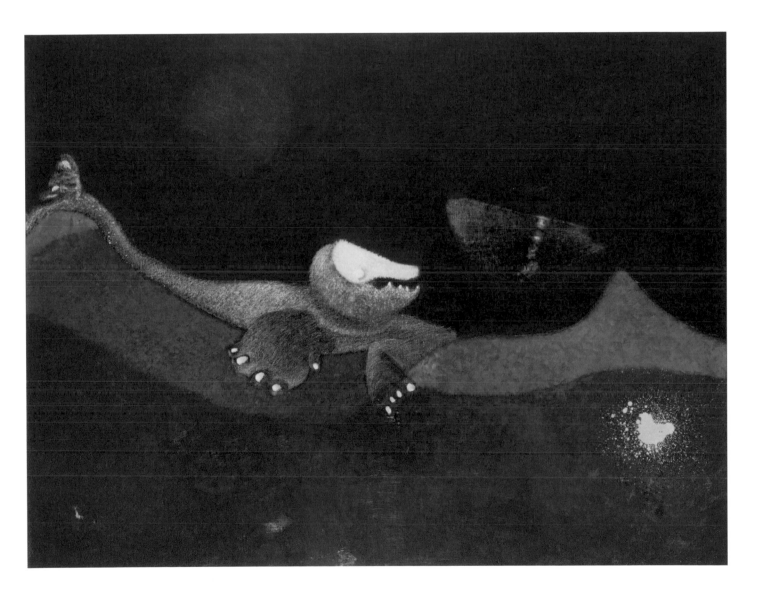

*A Virgin, a Widow
and a Wife,* 1956
Oil on canvas, 89 × 72.5 cm
(35 × 28⅝ in.)
Private collection

*Sign for a School
of Monsters,* 1968
Oil on canvas, 88 × 115 cm
(34¾ × 45⅜ in.)
Private collection

a famous salon picture painted by Alexandre Cabanel (1823–1889), which Max Ernst then painted over so that the erogenous zones were emphasized. This picture, with its goddess sleeping above the water, amounts to a homage to France with the Île-de-France being seen as the heart of the country's fertility. The title is a reference to the fruitful lowlands that lie between the Rivers Loire and Indre, an area where the artist himself lived between 1955 and 1963. The gardens, parks and agricultural areas, expressed here in different shades of brown and green, and the watercourses of the Loire and Indre, which are shown as flowing in opposite directions in order to confuse the beholder, form the bed in which the beautiful nude sleeps until the day when she will be woken.

The title of *Ubu, Father and Son*, which was painted in 1966, is not only reminiscent of a company name but also seems to indicate a survey of the products offered by this company. The assemblage of found objects, as well as collage and grattage are united here once again along with other techniques Max Ernst made use of. Like Loplop, Ubu the father, the anarchic villain and title figure of Jarry's play, introduces us here to himself and his nearest and dearest (cf. the passage on Ubu Imperator on p. 30).

This "introduction" reminds us once again of the changes in media that Max Ernst introduced to 20th century art, yet it also involves a repetition of subject matter, as does *The Return of the Fair Gardener* (ill. p. 80). However, Max Ernst was able to make use of the same subject matter throughout his life's work without the results becoming purely repetitive, due to the systematic trial and use of materials having "nothing to do with art." Through the changes resulting from such carefully guided "coincidences," Max Ernst gave both himself and us, the beholders of his work, the chance to discover new surprises in his work again and again.

A Swallow's Nest, 1966
Oil on canvas, 134 × 168 cm
(52⅞ × 66¼ in.)
Private collection

Ubu, Father and Son, 1966
Oil on canvas, 157 × 130 cm
(61⅞ × 51¼ in.)
Private collection

Page 90
Birth of a Galaxy, 1969
Oil on canvas, 92 × 73 cm
(36¼ × 28¾ in.)
Basel, Fondation Beyeler

Page 91
Rien ne va plus, 1973
Oil and collage on canvas,
27 × 22 cm (10¾ × 8¾ in.)
Private collection

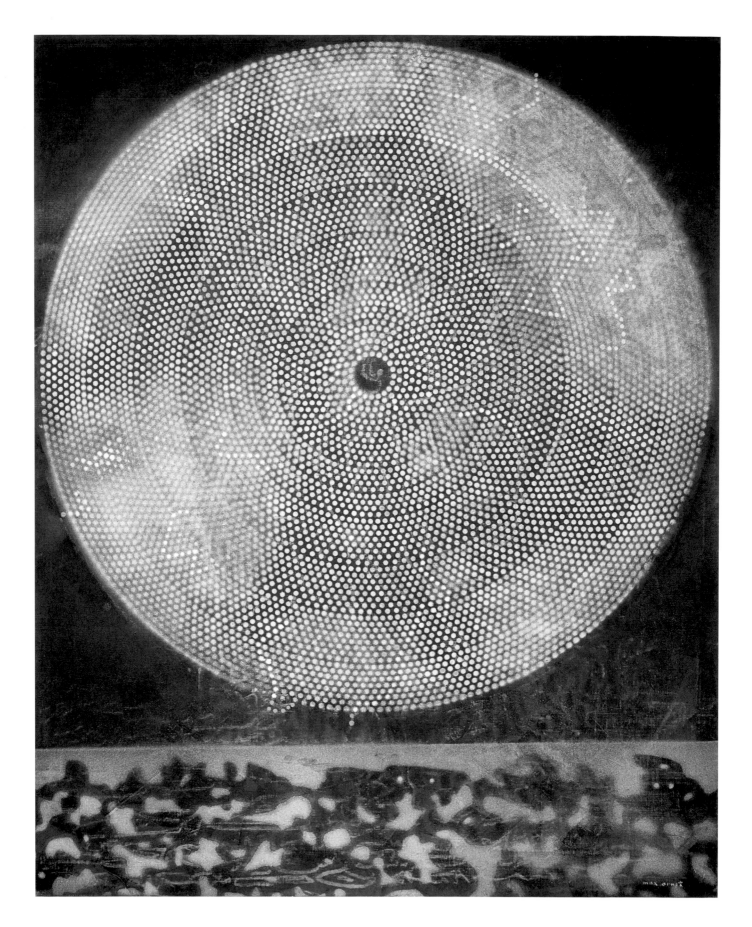

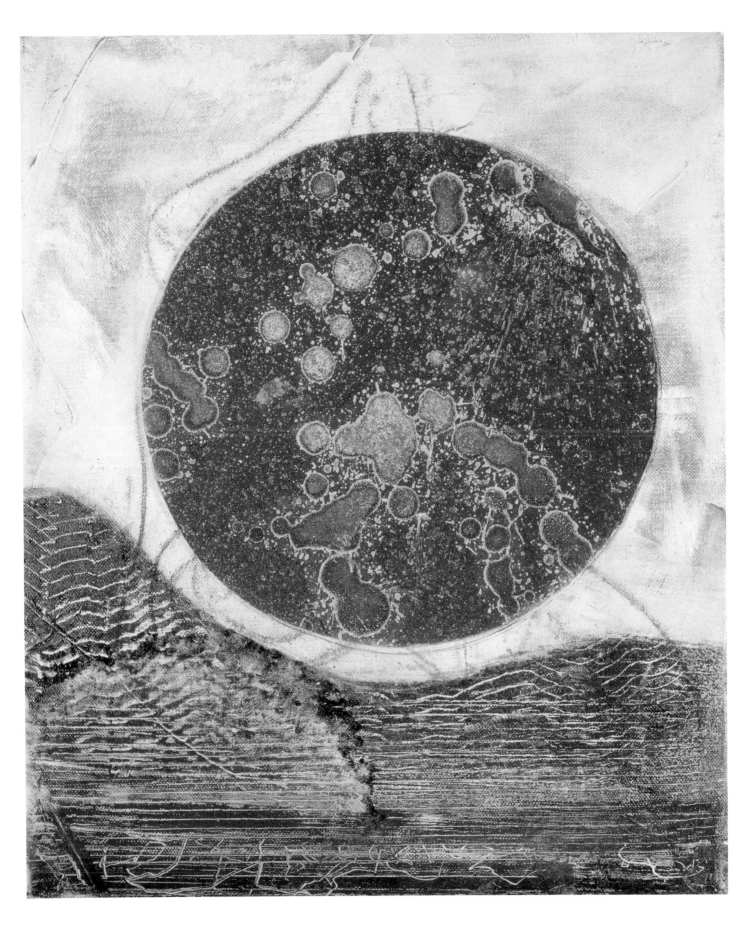

Max Ernst
1891–1976
Life and Work

1891 Born on 2 April as the first son of Philipp Ernst, teacher of the deaf and painter "with all his heart," and his wife, Luise, née Kopp. Childhood and adolescence in Brühl, the town of his birth, near Cologne.

1910–1914 Study of liberal arts at Bonn University.

1912 Visited the "Sonderbund" exhibition in Cologne; first encounter with the works of international modern painters such as van Gogh, Cézanne, Gauguin, Signac, Picasso, Matisse, Hodler, Munch and the German Expressionists.

1914 Acquaintance with Hans Arp; called up to do service with the field artillery.

1916 Took part in the "Sturm" exhibition in Berlin. First contact with Dada artists.

1918 Married Luise Strauss, a university friend, in Cologne.

1919 Visited Paul Klee in Munich. Saw reproductions of works by Giorgio de Chirico; first illustrations.

1920 Dada exhibition with Baargeld at Winter Brewery in Cologne closed on grounds of obscenity.

1921 Met Paul and Gala Éluard. Spent holiday with Hans Arp, Sophie Taeuber and Tristan Tzara in the Tyrol.

1922 Spent summer in the Tyrol.

1923 Exhibited in "Salon des Indépendants," Paris. Painted murals in Éluard's house at Eaubonne, near Paris.

1924 Journey to the Far East with Gala and Paul Éluard. Painted *The Fair Gardener* (ill. p. 29).

1925 Spent holiday at the sea in Britanny. Wrote story of origins of frottage, resulting in publication of *Histoire Naturelle* (ill. pp. 36/37).

1927 Married Marie-Berth Aurenche; horde and forest pictures.

1929 Published *La Femme 100 têtes*, a collage-novel (ill. p. 49).

1930 Acted in *L'Âge d'or*, by Luis Buñuel. Beginning of Loplop series.

1931 First exhibition in New York.

1934 Published *Une Semaine de bonté*, a collage-novel.

1935/36 Painted *The Entire City* (ill. p. 56).

1936 Exhibited 48 works at "Fantastic Art, Dada, Surrealism" exhibition at The Museum of Modern Art, New York.

1937 Painted *The Angel of Hearth and Home* (ill. p. 61) in response to his sense of helplessness with regard to the Spanish Civil War.

1938 Left Paris and moved to Saint-Martin d'Ardèche in South of France.

Dorothea Tanning and Max Ernst with the cement sculpture *Capricorn*, Sedona, Arizona, 1948
Photograph: John Kasnetsis
Brühl, Max Ernst Museum, Stiftung Max Ernst

Max Ernst at the age of five, with his sister Maria

Max Ernst at his easel, Brühl, 1909

Tristan Tzara, Maya Chruseces, Lou Ernst, André Breton and Max Ernst (from left to right) in the Tyrol, 1921

Max Ernst in Luis Buñuel's film *L'Âge d'or*, 1930

The Surrealist group at the Foire de Montmartre, *c.* 1924
From left to right: André Breton, Robert Desnos, Joseph Delteil, Simone Breton, Paul Éluard, Gala Éluard, Max Morise, Max Ernst

Max Ernst in his studio at Impasse Ronsin in Paris, 1952

1939 Beginning of persecution in France, first by French authorities for being an "enemy alien" and then by the Gestapo.

1941 Arrival in New York on 14 July. Ernst and Peggy Guggenheim were married at the end of the year.

1943 First stay in Arizona; met Dorothea Tanning for first time.

1946 Left New York to live with Dorothea Tanning in Sedona (Arizona) in a house he built himself. He married Dorothea in July in Beverly Hills.

1950 First journey back to Europe; worked in Paris.

1951 First comprehensive exhibition of his work in Germany, held in his home town, Brühl.

1953 Final return to Europe; lived and worked in Paris.

1954 Received the top prize for painting at the Venice Biennal.

1955 Moved into a house in Huismes near Chinon in the Touraine district.

1962 Retrospective exhibition at Tate Gallery, London; subsequently at Wallraf Richartz Museum in Cologne.

1963 Move to Seillans in the South of France (Provence-Alpes-Côte d'Azur).

1967 Painted *Return of the Fair Gardener* (ill. p. 80).

1969/70 Retrospective exhibitions in Stockholm, Amsterdam and Stuttgart.

1976 Died on 1 April in Paris, one day before his 85th birthday.

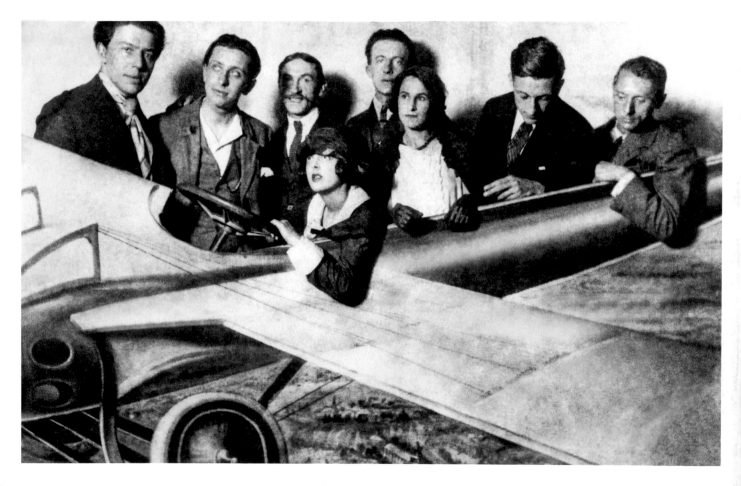

Photo credits

The publishers would like to express their thanks to the archives, museums, private collections, galleries and photographers for their kind support in the production of this book and for making their pictures available. If not stated otherwise, the reproductions were made from material from the archive of the publishers. In addition to the institutions and collections named in the picture captions, special mention is made of the following:

akg-images: 13, 20, 26, 33, 34, 42, 45, 52, 56, 57, 58/59, 60, 62, 70, 71, 73, 77, 82/83, 84
akg-images / André Held: 19
akg-images / picture alliance / Eventpress: 74
© Archives Charmet / Bridgeman Images: 94
Archive PL / Alamy Stock Photo: 1
© Art Institute of Chicago / Gift of Maurice and Muriel F. Fulton / Bridgeman Images: 10
Artothek: 76, 87, 90, 91
Artothek / Hans Hinz: 36
Artothek / Jochen Remmer: 9
Artothek / Westermann: front cover, 4, 63
bpk / Bayerische Staatsgemäldesammlungen: 61, 66
bpk / CNAC-MNAM / Philippe Migeat: 31, 46
bpk / Kunstsammlung Nordrhein-Westfalen, Düsseldorf / Walter Klein: 2
bpk / Nationalgalerie, SMB / Jens Ziehe: 79
bpk / Nationalgalerie, SMB / Jochen Littkemann: 78 above
bpk / Rheinisches Bildarchiv Köln / Britta Schlier: 28/29
bpk / Sprengel Museum Hannover / Stefan Behrens: 72

bpk / SSK / Raphael Maaß: 38 above, 38 below, 40, 41 below, 41 above right
bpk / Staatliche Kunsthalle Karlsruhe / Wolfgang Pankoke: 54
bpk / Städel Museum: 11
Bridgeman Images: 21, 30, 48, 55, 69, 75, 80
Digital image, The Museum of Modern Art, New York / Scala, Florence: 14, 15, 18, 24, 35
G. Dagli Orti / © NPL – DeA Picture Library / Bridgeman Images: 51
© INTERFOTO / fine art images: 68
© Israel Museum, Jerusalem / Vera & Arturo Schwarz Collection of Dada and Surrealist Art / Bridgeman Images: 12
Lehmbruck Museum, Duisburg / Jürgen Diemer: 78 below
© LVR-ZMB, Dominik Schmitz: 8 above
© Max Ernst Museum Brühl des LVR: 92, back cover
© NPL – DeA Picture Library / Bridgeman Images: 44
Photo © Christie's Images / Bridgeman Images: 86
Photo © Derek Bayes. All rights reserved 2023 / Bridgeman Images: 27
Photo courtesy of Mildred Lane Kemper Art Museum, Washington University, St. Louis: 67
Luisa Ricciarini / Bridgeman Images: 16
© Michel Sima / Bridgeman Images: 95
Wadsworth Atheneum / Allen Phillips: 64/65
© Peter Willi / Bridgeman Images: 22, 25
Yale University Art Gallery, New Haven: 37

The author

Ulrich Bischoff is an art historian and writer. From 1994 to 2013, he worked as director of the Gemäldegalerie Neue Meister at the Staatliche Kunstsammlungen Dresden. He has published extensively in the areas of classical modernity and contemporary art.

Imprint

© 2023 TASCHEN GmbH
Hohenzollernring 53, 50672 Köln
www.taschen.com

© for the work of Max Ernst:
VG Bild-Kunst, Bonn 2023

Original edition:
© 1987 Benedikt Taschen Verlag GmbH
English translation: Judith Harrison

Printed in Slovakia
ISBN 978-3-8365-9529-2

Front cover and page 4
Euclid, 1945
Oil on canvas, 65.1 × 59.1 cm (25⅝ × 23¼ in.)
Houston, The Menil Collection

Page 2
Teetering Woman, 1923
Oil on canvas, 130.5 × 97.5 cm (51⅜ × 38⅜ in.)
Düsseldorf, Kunstsammlung Nordrhein- Westfalen

Back cover
Dorothea Tanning and Max Ernst with the cement sculpture *Capricorn*
Sedona, Arizona, 1948
Photograph: John Kasnetsis